A NEW ATLAS OF AMERICAN STYLE

THE UNITED STATES OF FASHION

THE EDITORS OF *VOGUE*

RIZZOLI
NEW YORK

New York · Paris · London · Milan

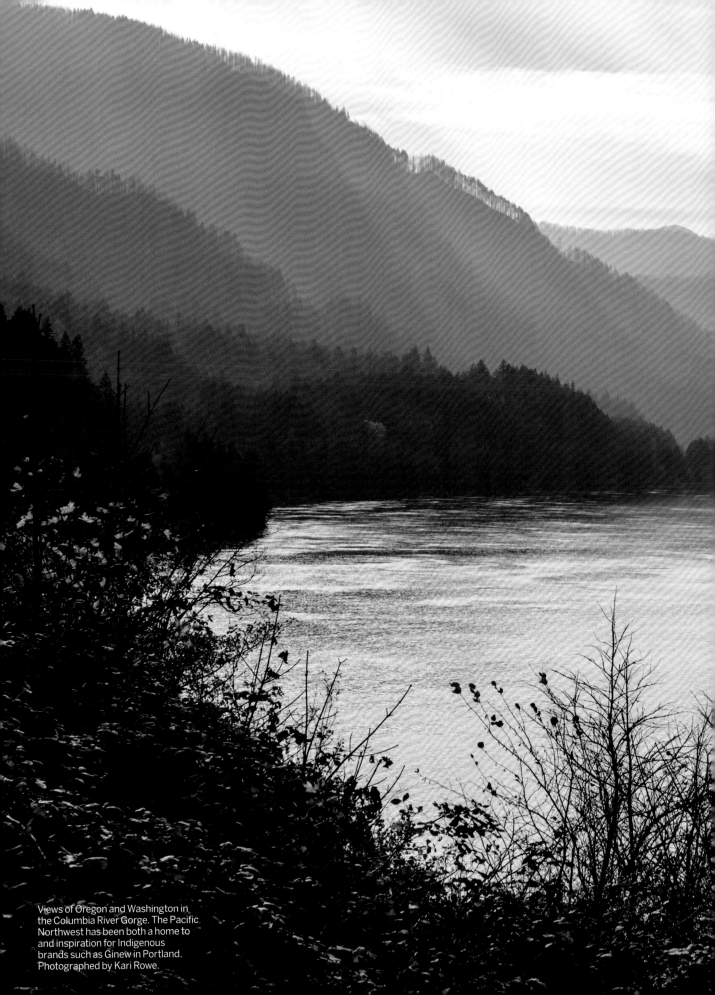

Views of Oregon and Washington in the Columbia River Gorge. The Pacific Northwest has been both a home to and inspiration for Indigenous brands such as Ginew in Portland. Photographed by Kari Rowe.

CONTENTS

FOREWORD ... 8
GROWING UP IN STYLE ... 11

THE UNITED STATES
OF FASHION:

THE EAST ... 29
THE MIDWEST ... 55
THE SOUTH ... 85
THE WEST ... 117

ACKNOWLEDGMENTS ... 175
CREDITS ... 176

FOREWORD

By Anna Wintour

Fashion is all around us. That is the unmistakable lesson of this book—a project that was conceived at a moment of profound challenge. Here's how it started: With the COVID-19 pandemic raging, and the country's fashion community reeling, the editors of *Vogue* decided to look closely at the heart and fabric of the industry, at this country's small and lesser-known designers, its best craftspeople and artisans. We wanted to see how fashion was still being made, how it was being dreamed up and constructed on the ground, in our local communities, from coast to coast. Nothing could be more important, we thought—especially at a time when everything seemed threatened—and nothing could be more intuitive than to look at our surroundings when we were locked down. The result—the book you are holding in your hands—feels, miraculously, like an outpouring of joy, a celebration of everything we cherish at *Vogue:* creativity, style, craft, democratic spirit, and resilience. American fashion is not in crisis. It's all around us. It's everywhere.

Drawing a new map of American fashion, as we came to think of what we were doing, demands a different kind of thinking—a perspective shift that feels natural as I write this in early 2021, but is actually quite profound. Where does American fashion come from? For decades the answer was simple: New York City, America's fashion capital, home to the runways of Fashion Week, the boutiques of Madison Avenue and SoHo, and the workrooms and showrooms of Seventh Avenue. New York was where designers came to launch their careers, where fashion dreams were made into reality.

And this was, in fact, true. Bill Blass forged his career here. So did Ralph Lauren. So did Carolina Herrera, and Oscar de la Renta, and Marc Jacobs, Donna Karan, Michael Kors, and almost all the significant American designers you might name. I built my own career in this city. New York was where it was all happening.

Well, not *all*. The importance of New York to fashion may be one of the settled facts of the last few decades, but certainly the city has never had a monopoly on creativity or style. American fashion has always had a much broader scope. We know this in part thanks to the CFDA/*Vogue* Fashion Fund, which was launched to cultivate a new generation of American fashion talent after 9/11. Applicants to the Fashion Fund have come from small towns and cities—across the South, the Midwest, beyond the Rocky Mountains, the Pacific Northwest. And when we remade the fund into the relief initiative A Common Thread after COVID-19 hit, the need was similarly widespread. There were hundreds of small fashion businesses across the country—and they all needed support. (I'm proud to say that A Common Thread has distributed over $5 million in grants to more than 128 small businesses since it launched in March 2020.)

Technology has played its role in the democratization of fashion, of course. It used to be that if you were a young designer, you needed to come to the biggest city and the biggest stage to find your customers and start your business. Social media changed that, as have the nimble, small-scale direct-to-consumer business models that so many young brands have embraced. No longer does a fashion designer in a small town risk feeling quite so isolated. Now her community, her fashion tribe, and her buying customers are right at her fingertips, a swipe away.

American fashion is at its best when it produces an idea of what America can and should be. And this shift—from New York to America, from Seventh Avenue to Main Street—is a more inclusive vision for the industry, and a more sustainable one too. Celebrating fashion at the local level means giving

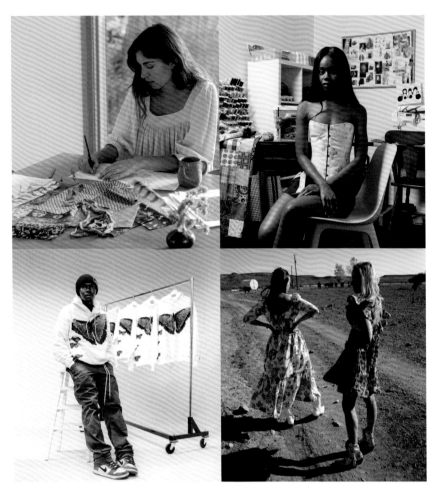

CLOCKWISE FROM TOP LEFT: Christy Baskauskas of the brand
Christy Dawn; designer Asata Maisé; Miron Crosby's Sarah Means and
Lizzie Means Duplantis; Unfinished Legacy's Brema Brema.

our support to small businesses and communities that need it, and forging that personal connection that can be so important to both designer and customer. Who makes the best beaded bag, or the must-have boot? Perhaps it's someone in your hometown.

In the pages that follow, you'll discover an amazing group of American designers—young and not so young, small and medium scale, established and quite new—captured by photojournalists and portraitists. We also asked many designers to photograph themselves—self-rendered images that are among the most intimate and charming pictures in this book. Our editors interviewed each designer and told their stories in short profiles included here. We divided the wealth of images and text into four regions—East, Midwest, South, and West—to give each part of this country its due. The result is a grand American tour from Tennessee to Delaware to Alabama, and from Nantucket to Detroit to Los Angeles to Chicago to Lodge Grass, population 428, located on the Crow Indian Reservation in southern Montana. This is truly fashion from sea to shining sea.

To accompany these images and stories, we also commissioned a collection of original essays from six distinct American voices who write about their experience discovering fashion growing up across the country. What did it mean to embrace goth in Miami? To fall in love with high style in Akron, Ohio? To celebrate indigenous fashion, from youth through adulthood? Reading these essays and the many pages that follow gives me an irrepressible feeling of pride. I see *The United States of Fashion* as a kind of companion volume to another *Vogue* book, *Postcards From Home: Creativity in a Time of Crisis* (Rizzoli, 2020)—a vision of ingenuity in changing times, and a pledge of optimism for a better, more united future.

GROWING UP IN STYLE

IN THE ESSAYS THAT FOLLOW, six American writers reflect on formative fashion experiences of their youth—and how place played a role in shaping not only how they dressed, but who they came to be. Like the photographs that populate the pages of this book, these narratives tell of the striking diversity that has always defined fashion in the U.S. The writers cover a broad and disparate territory—from Akron's department stores to Miami's goth emporiums to WASP enclaves on Philadelphia's Main Line—but they excavate a universal truth: Where we are going is always related to where we've been.

AMERICAN GOTHIC

By Suzy Exposito, *Miami*

When people think of Miami, it's hard not to think of its longtime status as the playground for foreign diplomats and socialites, not to mention many of the South's greatest rappers and athletes, all modern demigods partying away in Art Deco Mount Olympus. But chip away at the bleached-pastel veneer, and you'll find its more intriguing, Stygian side. This is the Miami I know best: a sinister place where murders of crows stalk green parrots in palm trees, feral cats rove North Beach, and a midday monsoon can flood your neighborhood for days.

Florida in the late '90s produced ghastly rock acts like Marilyn Manson and Jack Off Jill—and, eventually, sullen teenagers like me. I raided my Gen X parents' stash of alt-rock cassette tapes and Anne Rice novels in search of a persona to set me apart from my peers. By 2001, I had gone from wearing school uniforms splattered in paint to black hoodies, chokers, and wide-legged JNCO pants. My friends and I, enthralled by the formidable clique of witches in *The Craft*—or more familiar conduits to the spiritual realm, like our superstitious *tías* and the beloved Puerto Rican astrologer Walter Mercado—shared books about Wicca and the cosmos. Once we got a taste of the darkness, and the fear it inspired in our classmates—girls who wore striped polo shirts and denim flares—there was no going back.

There's a certain asceticism to being goth in hot weather. I would saunter across the open-air Sunset Place mall, the steel chains that hung from my pants burning to the touch under the eternal sunshine. My parents, my Cuban-American father and Belizean mother, who fell in love to the sounds of New Order and Depeche Mode, seemed bemused by my sudden goth turn. "Put on some shorts like the other kids," said my dad before dropping me off at day camp the summer before high school. "You're gonna get heatstroke!"

It was a life of agony, and it didn't come cheap. Once my dad started a job as manager of an Italian-Cuban café in the city of Hollywood, just north of Miami, he decided that I needed a work ethic more than I needed a pair of knee-high Demonia boots. And so I became a part-time barista at 14, serving cortados to go through a *ventanita*—a little window, a Cuban-American invention that predated the Starbucks drive-through. Like most first jobs, it was hardly hip. My uniform was a giant Italian soccer jersey, slung slipshod over my long-sleeved fishnet shirt and ripped jeans. I quickly took to eye rolling at leering comments from older male customers, but one day, two young guys with jet-black hair, face piercings, and tattooed biceps approached the ventanita with a look of recognition in their eyes. "Come to our shop," they said excitedly. "It's called Mosh Pitt. We'll give you a discount if you give us free coffee!"

I didn't yet know about Mosh Pitt. I knew, of course, about the famed chain store Hot Topic at Sunset Place: a dimly lit vortex where alt kids acquired band tees and other totems of nonconformity. But that had become the domain of raccoon-eyed cherubs, like a middle school crush of mine, a baby goth who'd rat on shoplifters in exchange for free Slipknot buttons. Though Mosh Pitt was stocked with many of the same wares, it seemed a step up for me: a worldly teen who'd just discovered Sonic Youth and the notion that where you bought something was almost as important as what you bought.

On an 85-degree day in February, I tossed aside my soccer jersey and marched down Hollywood Boulevard with two cappuccinos in hand. The smell of leather and frankincense wafted from the inside of the shop, where I found the guys from the café seated on a couch made from rubber tires, listening to Ministry. Hours later, I emerged with a laundry list of records to

SUZY EXPOSITO is a music reporter for the *Los Angeles Times*.

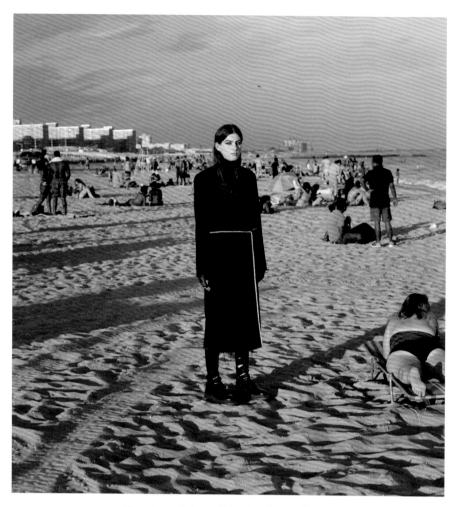

"There's a certain asceticism to being a goth in hot weather," Exposito writes. Photographed by Sam Nixon.

buy, a set of studded wrist cuffs, and a patent-leather corset-shaped purse that could hold only my tiny purple Nokia phone. But I also left with the sense that I wasn't just "going through a phase."

The tropical gothic style I cultivated as a teen would evolve as I got older and lived in New York, Paris, and now Los Angeles. It's a more versatile look, which incorporates my innate witchiness with my equally innate Caribbean Latina femininity: I pair gold hoops and hair wraps with heavy metal–band tees and black cigarette pants. I also go lighter on the hardware— gold jewelry with protective evil-eye charms and sigils that won't clash with my tattoos. It's a far cry from the year-round, brightly hued athleisure looks Miami girls generally sport, but one thing I learned from them is that statement sunglasses are a must.

My dad didn't work at the café forever; and when he got a new job, I never went back to Mosh Pitt,

which has since closed down. These days, when visiting family, I like to wander Miami's art district and peruse the Wynwood Shop, a haven for local indie vendors selling dainty skull stud earrings alongside punk-style pyramid bracelets, as well as Art By God, home to bizarre curios like taxidermy, crystal jewelry, and fossils. I might pick something up from Miami-based clothing brand Deep Antiquity, which specializes in light, summer-friendly goth wear, beach towels, and even votive candles, or get my nails done at Saints-N-Scissors, where the stylists cater to everyone but share an affinity with those for whom every day is Halloween. These stores and salons are generally uncrowded, but they're not empty either, and when I see a gaggle of sour-faced kids smoking outside Sweat Records, or mysterious women tossing roses into the ocean for Yemaya, I know a gothic energy is in the air—even if it is our little secret.

HERITAGE DESIGNS

By Louise Erdrich, *Minnesota*

I am a mixed-blood member of the Turtle Mountain Band of Chippewa, a tribal nation centered high in North Dakota, 10 miles from the Canadian border. My mother, Rita Gourneau Erdrich, sewed my clothes. Fashion starts in childhood. We instinctively love what is right for us. A dress of dark turquoise patterned with black flowers. A sparkling white pinafore with sunflower buttons. A pair of beaded moccasins made of tanned fawn skin, trimmed with red ribbon work. These were precious to me.

Like my background, my message has always been mixed. I went to college on a Native American Program scholarship wearing a denim miniskirt, brown tights, red cowboy boots, and my father's knit oxblood teacher's vest. In the '70s, out of college, joining American Indian activists, I asked my mother for a ribbon shirt and a calico ribbon dress, which I wore with a treasured Borsalino hat from my Italian boyfriend. The hat was like the fedoras my Ojibwe grandfather, a tribal chairman, rocked in the 1940s. I wore the ribbon dress and hat to rallies in Fargo and marches in Washington, D.C., demanding that the United States, which has a government-to-government relationship with tribal nations, honor the treaties that our ancestors made in good faith. If it seems frivolous to dress in a certain way to register outrage or make a political point, just look at the Native leaders of that time. They knew then, and Indigenous protesters know now, that to display pride in our traditions is a powerful statement.

For a time, as a young mother and writer consumed by care, I let my husband choose my clothes and even my hairstyle. I became a sedate Catholic matron for a few years. But then my mother sensed I needed to return to her protection. She made a dark-green dance shawl for me, patterned with prairie roses and beaded vines. A Turtle Mountain friend painstakingly sewed a traditional jingle dress for me, black with embroidered dragonflies, for courage. More recently, another Turtle Mountain friend gave me a blue skirt patterned with water droplets and appliquéd with Ojibwe flowers, a water skirt. I wore the jingle dress to dance with my daughters and other Native women at the George Floyd memorial in Minneapolis, and the water skirt comes with me on book tours.

In our traditions, women are in charge of water. These calico skirts, made opulent with stripes of satin ribbon, visibly state our responsibility. Peggy Flanagan, White Earth Band of Ojibwe and our current lieutenant governor here in Minnesota, proudly wears her water skirts and is loudly opposed to the Line 3 pipeline, which would disrupt our wild-rice beds, cross the headwaters of the Mississippi River, and contribute immeasurably to climate chaos.

Indigenous people create tribally specific clothing for many reasons—to express belonging, enter ceremony, show resistance, and to dance. Most important, I think our clothing makes a simple point. We are still here. There are 574 federally recognized tribal nations in the U.S. What we wear is unique to our particular tribal background. As I say, my look is always mixed but includes Chippewa, Ojibwe, or Anishinaabe influences, as well as Métis woodland-based patterns and complex flower beadwork. This style has been most beautifully interpreted by Métis artist Christi Belcourt, whose painting *Water Song* was used as the basis for several Valentino pieces in 2015.

In writing this, I don't want to invite the careless to don Indigibberish outfits like fake eagle-feather headdresses or plastic–bone pipe breastplates. So I'm going to divide Native apparel into two categories: sacred traditional and contemporary Native fashion. In the first category, there is the jingle dress, a healing garment that incorporates metal cones. The shaking of the cones is mesmerizing; the sound is meant to heal. The Mille Lacs Indian Museum and Trading Post in Minnesota recently hosted a show on the jingle dress, curated by Brenda Child, Red Lake Nation,

LOUISE ERDRICH is the author of over 20 books, including the National Award–winning novel *The Roundhouse*.

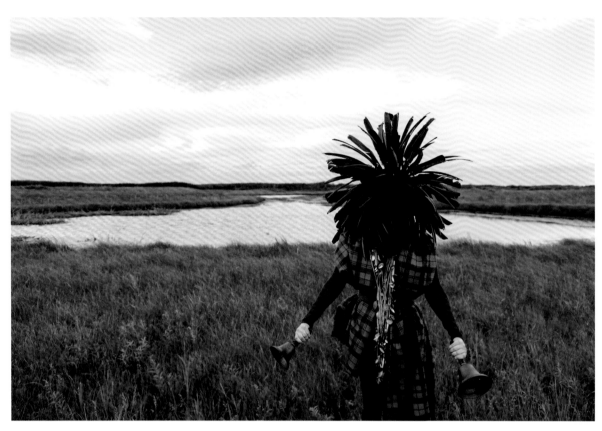

"Indigenous people create tribally specific clothing for many reasons," Erdrich writes, "to express belonging, enter ceremony, show resistance, and to dance." Artwork by Meryl McMaster.

that included a dress made from a woman's police uniform. The artist Maria Hupfield, Wasauksing First Nation, has created a jingle dress of regular blue-lined writing paper, printed with the names of over 500 North American Indigenous authors. Families all over Indian Country pool resources to outfit their powwow dancers in mind-blowingly elaborate regalia that is unrepeatable and impossible to mass-produce. How do you manufacture love?

In the second category, there's cushy footwear, perfect for working at home. As I write this, I am wearing a pair of moccasins from Manitobah Muk-luks, an Indigenous-owned company. The owner of Beyond Buckskin, Jessica Metcalfe, Turtle Mountain Chippewa, sources grassroots designers who incor-porate Ojibwe language into objects available from her online store. The nonprofit Honor the Earth sells bold graphic designs that anyone can wear to show solidarity with the Native fight for climate justice.

These days, the only way I have to express Indige-neity in public life is to wear jewelry, especially beaded earrings, on Zoom appearances. Wheels of antique beads made by Pe Hin Sa Win, Red Hair Woman, give me the comfort of a family friend. Josef Reiter's heavy Anishinaabe silverwork cuff gives me strength. Sweetgrass-trimmed birchbark circle earrings from my oldest daughter remind me to use our language. Another daughter made me a golden eagle–winged medallion that illustrates my Ojibwe name.

I know who makes the special things I wear. I know the history of each design. Each piece has meaning that gives depth to the moment, to the day, to my life. I wear adornment that keeps me close to my origins and to the earth; I have a rich connection with the people who make my favorite garments and jewelry. And I feel extra satisfaction when I wear something that expresses that relationship and also expresses me. Isn't that supposed to be what fashion is about?

THE TOPAZ ROOM

By Adrienne Miller, *Akron, Ohio*

At 14, all I wanted in the world was to be 40. What could have been more embarrassing and terrible than being a teenager? Adults were in charge, it seemed to me then, and adult life appeared to be governed by reason and rationality. I trusted adults. I had faith in adults.

Every Sunday when I was growing up, my parents would drive 20 minutes from my suburb on the east side of Akron to our Unitarian Universalist church on the west side. It was a great church. The congregants were freethinking, open-minded adults who worked to create an enormously accepting community, one that felt to me very far away from the slings and arrows of adolescence. The sermons that hit me the hardest were about how big the stakes were in adult life.

After church on Sundays, I would harangue my parents into taking me shopping across the street, at Summit Mall. This wasn't your standard mall; its anchors were a Higbee's and an O'Neil's—two excellent regional department stores—and this particular O'Neil's had a very special high-end fashion department: the Topaz Room. It was my own private portal to an adult world of elegance and grandeur, good manners and good sense.

Akron owed its past fortune to tires and Quaker Oats. In the '80s, when I was growing up, there were still plenty of vestiges of the city's former prosperity—the Civic Theatre, a tour de force of Moorish, atmospheric maximalism designed by the architect John Eberson, and the grand Tudor Revival mansions on Merriman Road. I remember going to the opening night of a play with my parents at the Goodyear Theater—Akron had quite a thriving arts community—and in a grand wood-paneled room stood an array of pastel-colored petits fours arranged on tiered silver trays. The Topaz Room was still heroically clinging to the last threads of this fading splendor. It was,

as Melissa Holbrook Pierson writes in her beautiful memoir *The Place You Love Is Gone,* the "sanctum sanctorum for the fashionable Akronite." But I didn't know that then. The Topaz Room felt as if it were my own private discovery.

My parents never had much of an interest in clothing, so they would drop me off at the Topaz Room and wait for me, sometimes patiently, sometimes not, in O'Neil's less dazzling departments. The Topaz Room was on the first floor, windowless, and located in the back of the store. When you entered, you found yourself in a tranquil, autumnal place bathed in sherry-colored light. The room always seemed to smell of some sort of mysterious spices. Were there candles? There must have been candles. Being in the Topaz Room was always a very emotional experience for me. It wasn't really about buying things. It had to do with my imagination—about what I wanted adult life to be. The saleswomen were always so kind, and they treated all customers, even children like me who had absolutely no business there, with equanimity. They'd let me loiter over the clothes, touch the clothes, try on the clothes in well-appointed, beautifully lit dressing rooms.

I remember guipure lace, cashmere Fair Isle sweaters, luxurious silk blouses with delicate puff sleeves, front-button midiskirts that I would have worn with lace-up riding boots if I'd had any. I remember Donna Karan bodysuits—a sage-colored silk one with small brass cuff links captured my imagination forever. There were exuberant patterned dresses. (Were they Ungaro?) A Calvin Klein Collection sweater vest, gorgeous camel-hair coats, chestnut-colored suede pants. I recall the meticulous gold embroidery on Carolyne Roehm jackets that would have fit right in at a salon in Vienna—in 1790. Who was wearing such finery in Akron? Where were they going? Could they take me with them? But maybe these were the wrong questions to ask.

To grow up in Akron meant that you didn't go around thinking you were any better than anyone else.

ADRIENNE MILLER is the author of the memoir *In the Land of Men* and the novel *The Coast of Akron.*

We were realists, clear-eyed observers of the truth. We were insecure that we weren't from Cleveland. Wearing fashionable clothes was seen as a suspicious activity because it was a way to set yourself apart from other people. I was beginning to develop another view. Was it possible that being dressed well was actually a way of showing respect for others? And isn't that what adults did? They treated other people with respect and dignity?

When I was 15, I finally found it. There it was, the pièce de résistance, hanging in a place of honor on a front rack in the Topaz Room: a pinstripe Ralph Lauren Collection pantsuit, navy blue and lined in silk. Wide cuffed legs. I tried it on. Simple, elegant, eternal. It was perfect then, it would be perfect now, it will be perfect forever. This, however, was not the sort of thing I could get away with at school. Acid-washed jeans were huge then. Big hair, scrunchies, Coca-Cola-branded sweat-clothes. In the warmer weather, kids at school (boys and girls both) would wear Jams (remember Jams?), tropical-patterned shorts that hit right above the knee. I did not approve of any of this. I was just an everyday sort of girl, with braces and a bad complexion, but it seemed so very important to respect yourself and to respect others enough to dress with adult-level dignity.

The main problem with the Ralph Lauren suit: I couldn't afford it. Of course I couldn't. I was 15. But I did have a job, sort of. I babysat the two kids who lived next door. Word of my babysitting services soon got out in the neighborhood, and another set of parents asked if I'd babysit for them, and then another. Pretty soon, I had a sweet little business

going. That babysitting money added up. I saved every dime. I happened to have been born a middle-class person at just the right time, and in just the right place—in the glory days of a somewhat faded but still-magnificent city—and I needed the babysitting cash for one thing only: the suit. Every Sunday after church I'd ask my parents to take me back to the Topaz Room to confirm that the suit was still there. It always was. Sometimes I'd try the suit on again. Eventually, it was moved to a sales rack in the back of the room. The Sundays passed, and I watched as the price on the tag was cut, and cut some more. (The Topaz Room always had such tremendous sales—a warning sign I didn't know enough about the world of commerce to heed.)

With my cobbled-together babysitting money, accumulated over the course of many months, I was finally able to buy the suit. Naturally, I wore it to my main babysitting job. I loved those kids and treasured them enough to be ludicrously overdressed as I made them boxed macaroni and cheese, and as we watched *Ladyhawke* for the 10,000th time. When I wore the suit to school, the formidable French teacher, on study-hall duty in the cafeteria, approached me at the long table. She leaned down to speak. (But why? I didn't even take French.) "You look very *adult*," she said. This remains one of the most exciting moments of my life.

In my 10th-grade class picture, I'm wearing my glorious pinstripe suit. My braces had just come off, and I'm smiling as I'd never smiled before. I looked like a child playacting the part of an adult, but what did it matter? I was so happy. The Topaz Room taught me that clothes are dignity. They are joy.

"There it was, the pièce de résistance: a pinstripe Ralph Lauren Collection pantsuit," Miller writes. Photographed by Hans Feurer, *Vogue*, 1984.

Dresses from Max Raab's Ladybug line,
which artfully evoked "summers on Nantucket,
football weekends at Yale," Lee writes.

THE WALLFLOWER

By Andrea Lee, *Philadelphia*

Why do you have so many little floral prints that you never wear?" demands my daughter, rifling through a rarely visited corner of my closets. Upstairs in our family house in Turin, Italy, she is as usual ransacking my wardrobe for vintage clothes—an Alaïa leather skirt, a Tom Ford for Gucci velvet jacket—that she will cajole from me for extended loans. "Stuff like this doesn't look good on you," she adds with daughterly bluntness, holding up a blouse from the Italian company Frau Lau, with a minuscule Liberty design of pale-blue blossoms. "Not your style at all."

It is true, I admit, that it is not my style, which is monotone, severe, yet occasionally reckless, ideally with an edge of kink. Yet it is also true that, over the years, I have made countless impulse purchases of garments strewn with tiny flowers: Laura Ashley blouses, prairie skirts from street markets, or French sundresses dotted with petite rosebuds. I rarely, if ever, put them on. They end up hanging behind my "real" clothes, yet when I catch an occasional glimpse of those meek, meadowy prints, I feel a curious sense of contentment. Their significance lies back in the Philadelphia of my childhood, when my 11-year-old fantasies of identity and style intersected with the sweeping vision of an extraordinary fashion entrepreneur and fellow Philadelphian. This was Max Raab (1926–2008), whom *The New York Times* once called "The Dean of the Prep Look," and whose labels, The Villager and its junior line, Ladybug, through the 1960s and early '70s enveloped the suburban girls of America in acres of floral cotton.

 ANDREA LEE is the author of five books, including the 2021 novel *Red Island House*.

It was in seventh grade that I became smitten with Raab's creations. The memory is vivid: French class on a gray November morning at the Baldwin School, a very affluent, very Waspy girls' preparatory establishment in Bryn Mawr, where, that fall, I had earned a mild notoriety as one of the first two Black students. It was the half-day before Thanksgiving break, when we were allowed to abandon our dreary uniforms for street clothes, and the classroom was awash with *jeunes filles* suddenly *en fleur*—dressed in A-line skirts and pin-tucked blouses in an effulgent mass of pastel shades, with designs of tiny blossoms covering everything that wasn't Shetland wool. I, wearing an unmemorable skirt and cardigan that had passed muster at my Quaker elementary school, was riveted. The sight of that multicolored plumage on my chattering classmates shone a stark spotlight on my status as an outsider, illuminating as well what I suddenly recognized as a passionate longing to belong to their ranks. It was a wrenching moment: the first time I saw fashion as an elemental force, something that one had to learn to navigate or be swept away by, something that could reveal deep secrets about life, something that could break your heart. In my first few months at Baldwin, I had experienced no overt racism but had slowly gained, day by day, the indisputable knowledge that all social doors were firmly closed to me. Those flowery prints seemed part of a walled Arcadian garden shut away behind those doors, but inside me a small, duplicitous voice whispered that if I just bought the clothes, I might be able to scale that wall.

If I had been asked back then who created such enviable garments, I'd have envisioned a patrician figure out of *The Philadelphia Story*. It was only years later that I learned that the creator of The Villager was no WASP aristocrat but a Jewish businessman with a picaresque past. Son of a Philadelphia garment manufacturer specializing in cheap blouses, Raab was a high school dropout who pumped gas and drove a taxi before discovering his talent for interpreting the zeitgeist. Observing the rich girls in Philadelphia's suburbs, he intuited that they were in search of clothes that expressed their mood in that transitional period between the conventionality of the early '60s and the youthquake that shook the end of the decade. He designed women's blouses and dresses with studiedly demure silhouettes, using a palette of "country" colors with names like Cornflower, Wild Cherry, and Dusty Olive. The effect was sporty, but with a touch of subversive romance, like a John Cheever story. It was aspiration that Raab was selling—summers on Nantucket, football weekends

at Yale—and with it, he built a fashion empire worth $140 million. "Waspy women love the classic suburban look," he said, summing up the social dynamic in a *People*-magazine interview, "and Jewish women want to look like WASPs." And so, also, did some young Black girls; it was all about belonging. In a period when there was little diversity on display in the media, our desires were shaped by what we saw.

Only my elegant mother, who shopped at Wanamaker's and Bonwit Teller, remained—like her future granddaughter—immune to the charm of tiny rustic prints. She, who loved Harris tweed and Bally shoes, refused to buy me anything she deemed a fad. Although she and my father—a minister and civil rights leader—appreciated the academic excellence of Baldwin, they were concerned about the emotional toll exacted by their daughter's pioneering into what they jokingly called *the* "lily-white planet," and constantly attempted to bolster my confidence with exhortations to be proud of who I was. I never revealed to them the extent of my passion for that particular look, because that might have exposed my prep school Stockholm syndrome, my disloyal secret yearning to be, in fact, *not* who I was, but a Main Line debutante instead.

By the time that I was allowed to choose my own clothes, the Villager craze had deflated, overwhelmed by the beads and fringes of late-'60s counterculture, what Max Raab ruefully described as the "blue-jeaning of America." In 1969, Raab sold off the company at a loss; and I too had jettisoned my dreams of The Villager the way one dumps a first crush. I had begun to enjoy being a maverick, a Black girl who loved Leonard Cohen and who composed moody poetry, who'd found a niche as part of a small clique of arty friends. Soon I departed for Harvard, where, in patched jeans and vintage fur coats, I studied literature and laid the groundwork for my ambitions of becoming a writer and traveling the world. By the time I published my first book and moved to Europe, I had forgotten that I'd ever longed for admittance to the bland pastures of WASP style.

Or had I? Years later, when my daughter pointed out my cache of floral prints, I realized that they represented a vestigial remnant of that longing. Every woman has a shadow wardrobe, outfits that suggest an alternative identity, a road not taken. I see mine as a shrine to past desires and the tenebrous aspects of self-invention. Those half-hidden clothes are reminders of a particular, now lost, era of American fashion, but above all they pay homage to how desperately a young girl can want something, and to a time of life as evanescent as spring blossoms.

THE COOL CROWD

By Dana Spiotta, *Orinda, California*

There is a photo of me at my eighth-grade graduation from Orinda Intermediate School in 1980. I am a doughy, awkward 14-year-old in a cream-colored Gunne Sax dress and strappy, mid-height cork-wedge sandals. I remember insisting the dress had to be Gunne Sax, and it had to be white, because that was what all the girls were going to wear. Gunne Sax was a popular '70s San Francisco brand known for a very specific style: flouncy, gauzy, sort of prairie Victorian. Needless to say, the fussy dress was particularly unflattering to my plush middle. I hated the dress, in fact. But I wore it because I wanted more than anything to fit in, to be accepted.

That summer, I was determined to make a fresh start of high school. Here was my opportunity to crack the rigidly enforced code of cliques. First I would cut my long hair. I loved my long hair; it was smooth and straight and hung to my lower back. All year I had been teased about it. After seventh grade, my father changed jobs and we had to move to California from Rome, where I had attended an all-girl Catholic school. We had uniforms: white oxford shirts, blue sweaters, and watch-plaid skirts (no shorter than just above your knee). There was little room for competition on the clothes front—we all looked dowdy. And, without boys around, we were free to be outspoken, smart, kind even. I remember a lot of arm locking, hand-holding, and hugging. Orinda was a small, conservative, wealthy suburb of San Francisco. (It would become infamous a few years after I left as the place where one girl stabbed and killed another girl because she was jealous that she hadn't made the cheerleading squad.) School in Orinda was, frankly, a vicious place of privilege and competition. Even the teachers favored the popular girls and disdained the "weird" kids. The stakes were high—I was not popular, but I was not hated either. I was lumped in with the nerdy kids; I had a couple of friends. But at any minute, I could be ditched and sent plummeting to an openly hated group. It was brutal. I had to make sure I fit in.

Many girls had the Dorothy Hamill cut, a sassy wedge that looked cute with earrings. If girls had long hair, it almost certainly was layered like Farrah Fawcett's, with curled, wingy bangs. I got the cut. But I never really mastered the art of using a curling iron (curl under, and then comb back in a feather), so I could never get it to look right; it just hung in sad commas on either side of my center part. I also made my mother buy me pastel Izod or Ralph Lauren polo shirts, which were worn with pulled-up collars. I wanted turtlenecks under yellow Fair Isle sweaters, like Elizabeth McGovern's in *Ordinary People*. I planned to pull my tiny gold locket on a chain up and out so it would hang just-so out of the top of the turtleneck.

I remember the outfit I chose for the first day of high school, an insipid lavender cotton cardigan with snaps instead of buttons and matching lavender high-waisted pants with, yes, lavender ballet flats. It was very matchy-matchy, and I did not "pull it off." As freshman year progressed, I kept my head down, and the popular girls occasionally smiled at me. I knew my place and did not try out for cheerleading, for which there were three teams. All the cheerleaders wore expensive, cute cheer outfits on game days, which seemed to be every day.

I noticed one group of kids who did not dress at all like the popular kids. They hung out in one area of the parking lot at lunch and played music on a tape deck. I was warned to stay away; they took drugs and went to nightclubs in Berkeley. They were not popular, and they were a little scary to me, even though I owned many of the records they listened to (Talking Heads, Elvis Costello, Blondie, The Clash. I had a huge record collection, from Eddie Cochran to the Beatles to Bowie to Television. The popular girls listened to Rush or Bruce Springsteen. I had

DANA SPIOTTA is the author of five novels, including 2021's *Wayward*.

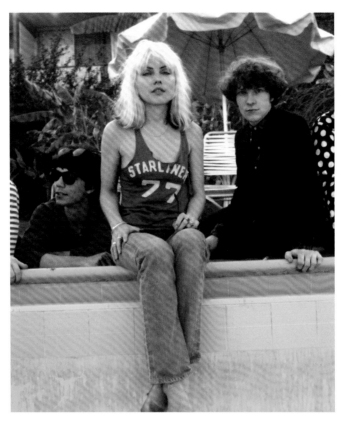

"I noticed one group of kids who did not dress at all like the popular kids," Spiotta writes. Blondie, photographed in L.A. in 1977.

those records too). I watched them from a safe distance. Some of the boys had short hair and stovepipe pants. They wore Chuck Taylor high-tops or thick-soled creeper shoes. A few of the girls wore fingerless gloves, tight black jeans, and layered tops, with tons of smeary eye makeup and red lipstick. (The popular girls wore a sharp line of blue or black on the inside of their lower lashes. Blue shadow on top. Lip gloss.) Others had vintage rayon dresses that they wore over jeans and then cinched with a concha belt. But one girl among them fascinated me. I remember her in a jacquard gold minidress with white lipstick and cat-eye liner. Her hair was short but back-combed into a mini beehive. Once she caught me staring at her, and I looked away. I remember also a kind of stewardess A-line dress with go-go boots. Where did she get those clothes? I knew there must be vintage-clothing stores in San Francisco, but in that pre-internet age, I didn't know where to begin. How did she get to be so free, so different? I wanted to talk to her, but I did not.

Then in December, I was in our den doing homework while my dad watched *Monday Night Football.*

They announced that John Lennon had been assassinated in front of his apartment. Of all the records I had, the Beatles' were the most precious to me. I was devastated.

I went to school the next day, that world of popped collars and cheerleader skirts and Rush. And then I saw her: She wore a cream shantung dress suit with white tights and white kitten heels and a wide black mourning armband over her jacket sleeve. Her expression was sober and serious. I was struck. What she wore communicated something to the world, to me. She felt what I felt. I belonged with her, with the weird kids, not with the Gunne Sax dresses and the feathered hair.

It took until the next year for me to change. Over the summer, we moved to L.A. It was my big chance to go New Wave. I discovered Melrose Avenue—a street of thrift stores, record shops, and edgy boutiques. I bought some vintage dresses, got some jeans at Fred Segal and had the ankles tapered in. Clothes I liked. Clothes I looked good in. Of course, when I arrived for my first day at this urban, arty high school, everyone was dressed like that.

PATTERNS OF THE PAST

By Susan Choi, *South Bend, Indiana*

Historians of fashion seem to agree that by the time I was born, in 1969, the sun was already setting on the Golden Age of Sewing, but there were few signs of this decline where I was growing up, in South Bend, Indiana. My mother, like so many mothers, owned a sewing machine and knew how to use it. How had this come to be? I asked her recently. She gave a verbal shrug over the phone from Houston, where she lives now. "If you read the directions and followed the pattern, it would come out all right," she recalled. She didn't even remember, perhaps because they were as ordinary to her as grocery shopping, our trips to the fabric store.

Oh, the fabric store. Even now, decades later, when I google those words and look at the photos, my heart thumps with desire. To be clear, these are not photos of fabric for sale online, but photos of the interiors of actual physical places where one goes to touch bolts of fabric and cards of rickrack, buttons buttoned to a stiff cardboard backing or tumbling loose in a jar. Dispenser displays of thread arranged by color, the spools' curved surfaces gleaming like candy, and every kind of beautiful ribbon, in every color and texture and pattern. The fabric store, unlike the grocery store, made me hungry, though for what, exactly, wasn't clear at the time. It was something much larger and much less defined than the outfits my mother would make from the items we chose, the fabrics and notions and trim. But the outfits I loved with my whole heart and remember as clearly as if they still hung in my closet: the ruffled pinafore made from a white-on-white print of tiny flowers trimmed with red rickrack and finished with an appliqué of juicy strawberries on the bib; the shirtdress of a multicolor cotton printed with a pattern to resemble embroidery; the truly glamorous halter dress with a triple-tiered skirt of pastel blue, pastel pink, pastel yellow. "Wow," says my mother, now in her 80s, on the other end of the phone, as I lovingly describe her creations. She's impressed I remember so well. She has zero memory of sewing me any of these things, though she does remember making herself a dress with extremely big sleeves—"They were in style that year." She says she wore it a few times and decided the sleeves looked so stupid that she tore them off and wore the dress sleeveless.

The fact that unlike me, my mother is white—exceedingly pale, small-boned, blue-eyed, and with the cheekbones of a film star—both oppressed me throughout my childhood and lay somehow outside of thought. Even to articulate it now feels uncomfortable. But the facts were, and remain, that my pale, blue-eyed mother never matched my black-haired, brown-eyed, dark-skinned self—always far darker as a child than I ever get now, because I was outside all summer in an era before sunscreen. In elementary school in Indiana, I was cast as the lone Indian in the Thanksgiving play. More generally, I was constantly looked at, especially—or, at least, so it seemed to me—when standing next to my mother. We didn't match. I harbored a fantasy, half fearful, half escapist, that I would turn out to have been adopted from some faraway land. Even my father—who really was from a "faraway land"—only explained my appearance, without removing my anomalousness. He was too anomalous himself.

Hence that hunger I felt at the fabric store, larger than any one outfit could satisfy. For the choosing of the fabric, and the notions, and the trim, was always secondary to the choice of the pattern—and the choice of the pattern was never, I understand now, about the pattern itself. It was about the girls, the winsome, the willowy, and the overwhelmingly—with token exceptions—white girls who modeled the pinafores and shirtdresses and halters, the tiered skirts and even the full-body pajama-like Halloween costumes on the outsides of the rectangular envelopes housing the patterns. Remember those? Remember how they were often filed

 SUSAN CHOI is the author of six books, including the National Book Award–winning novel *Trust Exercise*.

in boxes so that your fingers walked through them, as they would later walk through LPs at the record store? When I think of patterns, my mind says "Butterick," and I'd bet that the majority of the clothes my mother made me were from patterns put out not by Simplicity or McCall's but by the Butterick company—which also produced Vogue Patterns, having licensed the name from Condé Nast. Perusing those patterns of my past online, where especially on Etsy they abound as if the Golden Age of Sewing never ended, I have to wonder if I always chose Butterick patterns on the strength of the package illustrations alone. The Simplicity girls are oddly wooden and slightly misproportioned; the McCall's girls look like cartoons. But the Butterick girls still quicken my heart. I recognize my secret childhood self, that lanky-limbed, flush-cheeked, auburn-haired, spirited white girl I was deluded enough to imagine I might be, twin sister to Anne of Green Gables no less than to miniature Arrietty Clock.

Recognizing that hopeless longing to be entirely unlike myself—delicately white, as affirmed by 100 percent of my world—is a part of moving past it, and perhaps even a part of reclaiming those buttons and bows, those bolts of every possible fabric, delicious all on their own. After concluding from online photos that it might well be the store of my childhood, I called Stitch 'N Time, in South Bend, but it had only opened in 1993. "There was a fabric store back then on Ireland Road, by the old Scottsdale Mall," the woman who answered Stitch 'N Time's phone told me, when I explained where I'd lived. Fashion Fabrics, it turned out, had opened in 1971, just in time for my first toddler outfits—and closed just under two decades later, having withstood even the machine-made onslaught of Gloria Vanderbilt. "I know about that store because I worked there," the Stitch 'N Time woman went on, but before I could exclaim that maybe she had helped me choose buttons! Or ribbons!—she politely ended the call, an actual customer having arrived. Looking, I imagine, for the modest but real transformation that a pattern and some fabric can provide.

"Oh, the fabric store," Choi writes. "Even now, decades later, my heart thumps with desire."

THE
UNITED
STATES
OF
FASHION

Meet the diverse crowd of designers, visionaries, artisans, and heritage-keepers working all across this country, imbuing their creativity with craft, history, and a focus on community. Together, they're redefining the rich tapestry of style in America today.

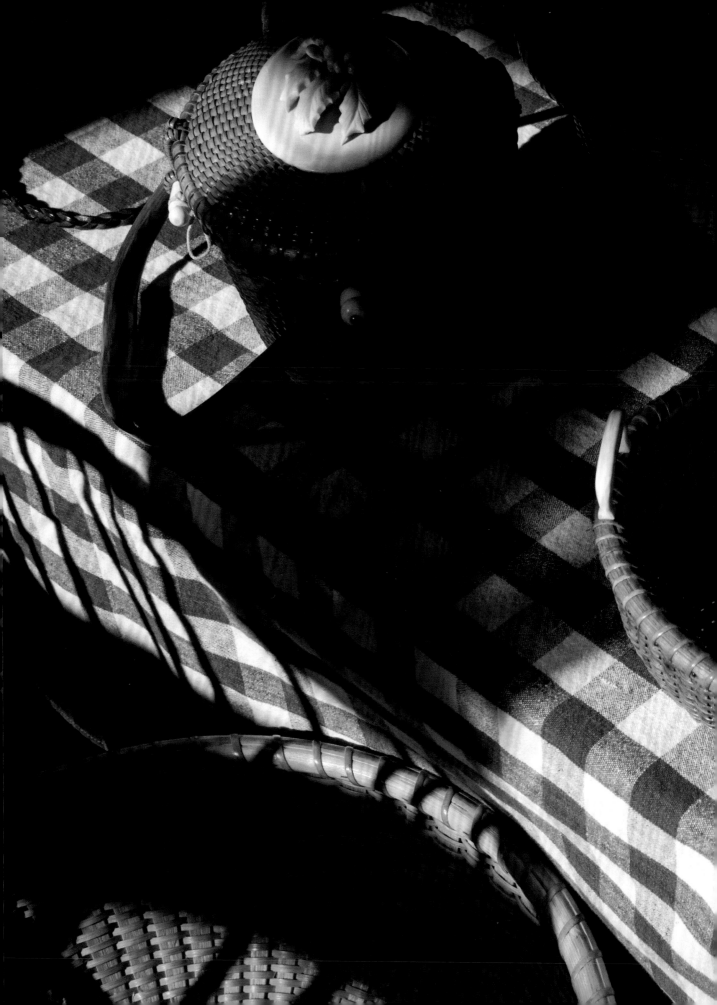

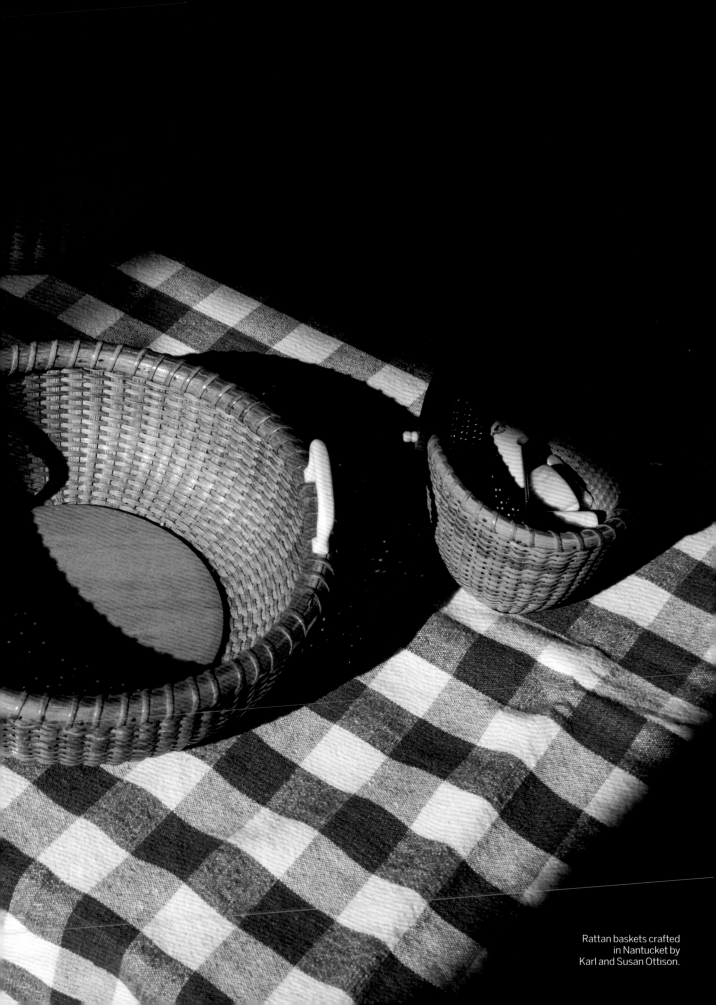

Rattan baskets crafted
in Nantucket by
Karl and Susan Ottison.

THE EAST

NEW YORK CITY MAY HAVE the cachet, but in places like Nantucket; Franklin, New York; and Washington, D.C., a score of designers both new and established are proving that good style (and strong followings) can crop up anywhere. In the pages that follow, you'll meet, among others, JBD Apparel's Saudia Islam who, despite Manhattan's seductions, has stayed put in her native Philadelphia. "The pandemic made me realize that I'm able to run a business in a place that I want to run a business from," she says, speaking for many young entrepreneurs. In Wilmington, Delaware, Asata Maisé—who moved back to her home state in 2019—feels much the same way. By collaborating with local creatives, she says, "we create our own sense of community in our own hub."

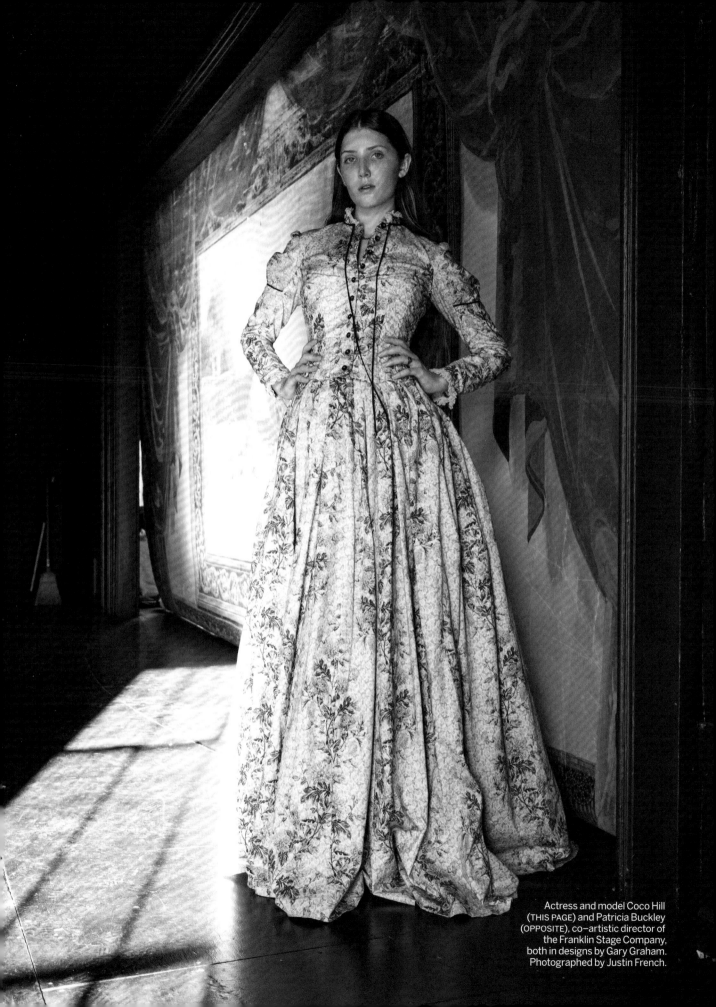

Actress and model Coco Hill
(THIS PAGE) and Patricia Buckley
(OPPOSITE), co-artistic director of
the Franklin Stage Company,
both in designs by Gary Graham.
Photographed by Justin French.

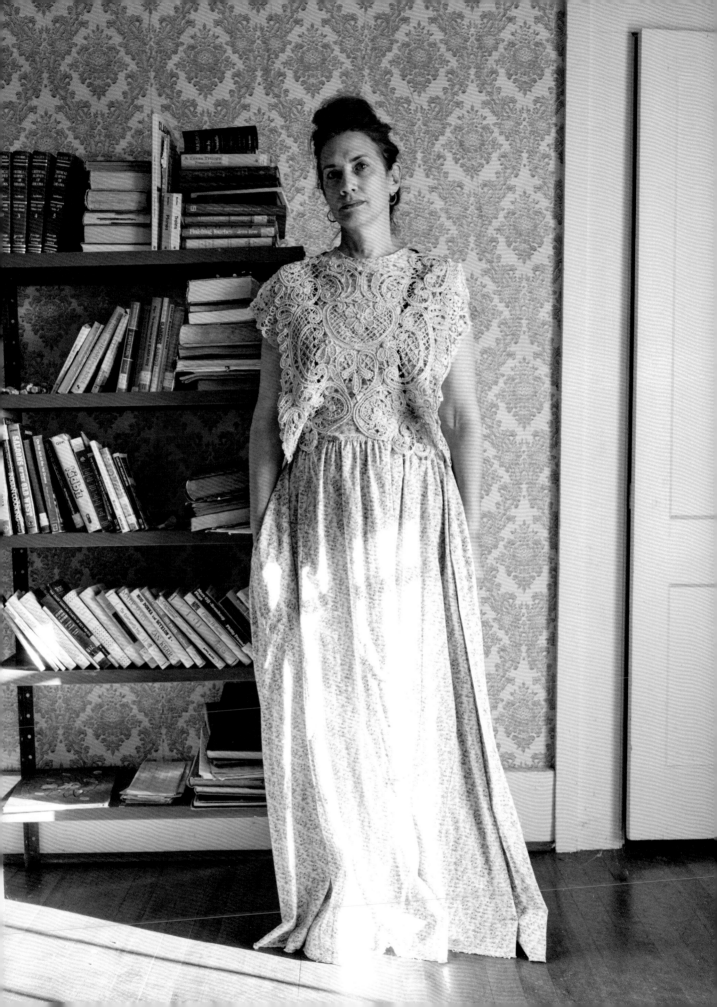

GARY GRAHAM, FRANKLIN, NEW YORK
Since Gary Graham moved out of a basement studio in Tribeca and into a historic storefront in Franklin, New York, in 2018, the sun has seemed to shine on this onetime CFDA/*Vogue* Fashion Fund finalist. Retailers including Joyce Hong Kong have come knocking, drawn by the designer's one-off pieces for his label, Gary Graham422, most made from vintage textiles. With both room and headspace aplenty, Graham has started to expand the elaborate, fictive narratives he constructs to include real people—and think about new, ever-more-responsible ways of doing things. "Glamour has always alluded to a sense of disguise," he says, "but these days, transparency has its own sense of glamour."

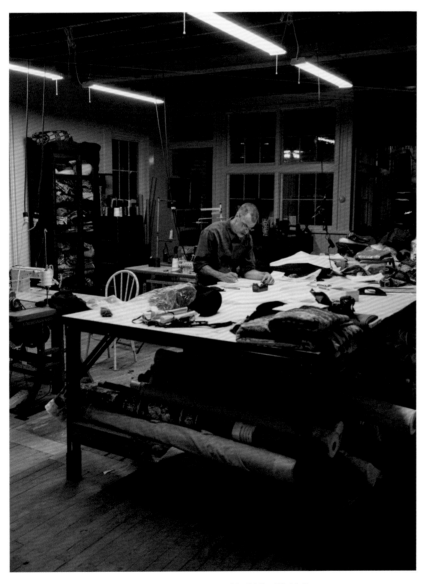

ABOVE: The designer, at work in his studio. OPPOSITE: Model Sophia Hall in Gary Graham422. Photographed by Justin French.

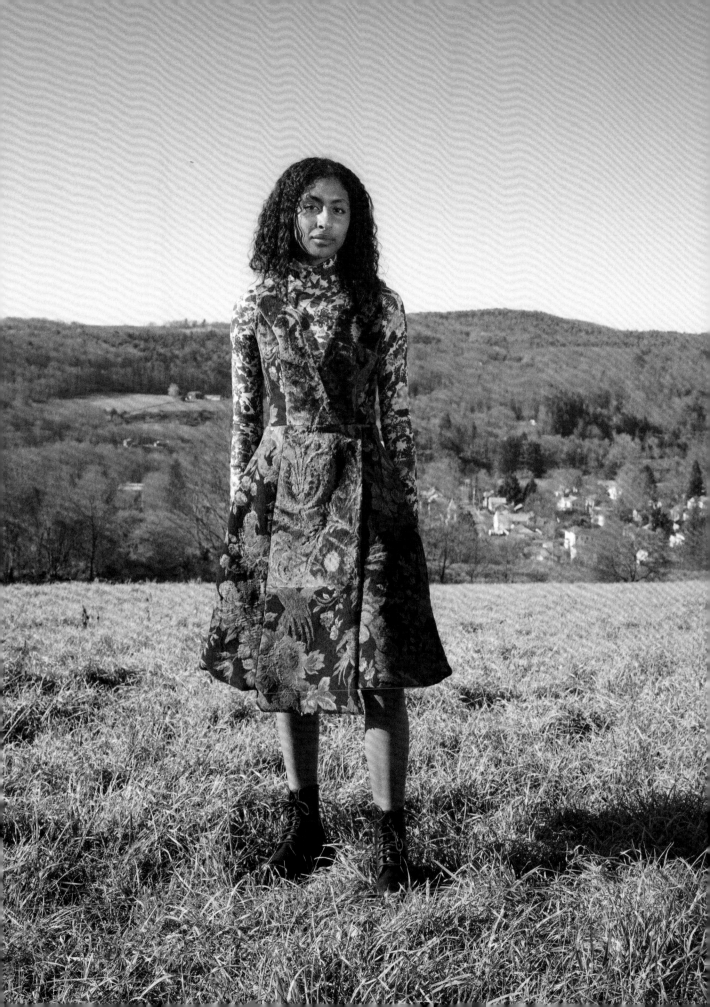

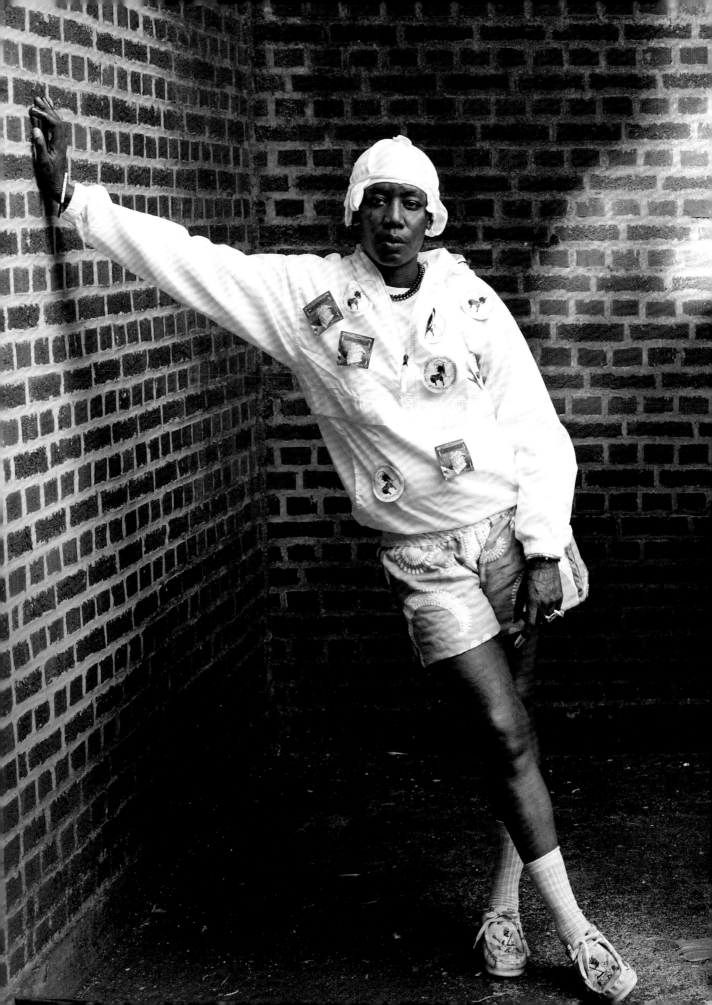

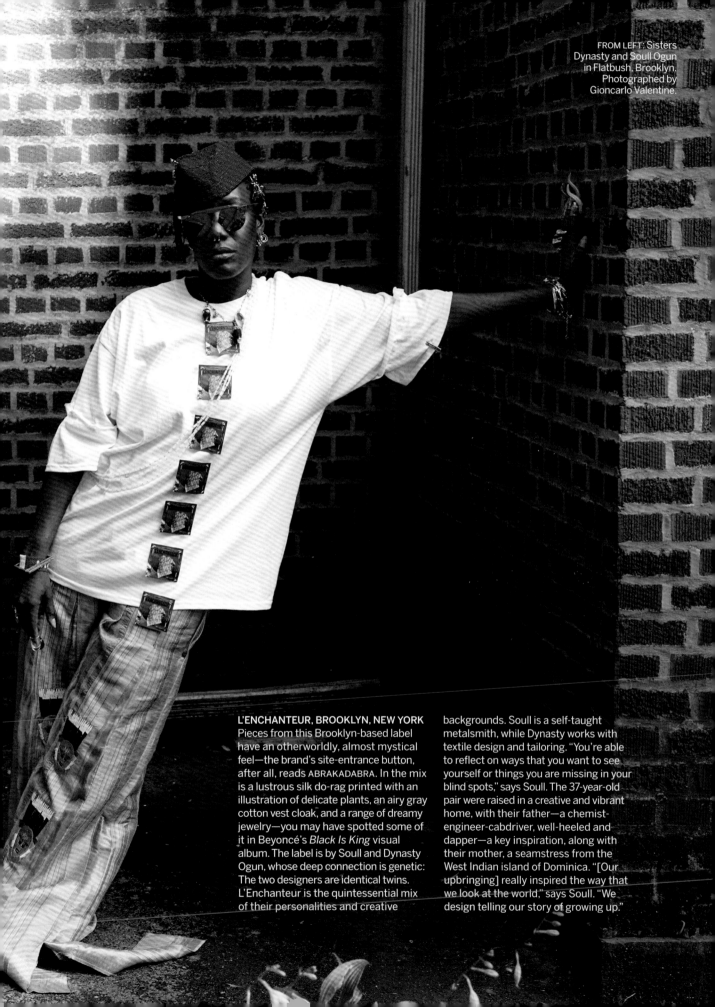

L'ENCHANTEUR, BROOKLYN, NEW YORK
Pieces from this Brooklyn-based label have an otherworldly, almost mystical feel—the brand's site-entrance button, after all, reads ABRAKADABRA. In the mix is a lustrous silk do-rag printed with an illustration of delicate plants, an airy gray cotton vest cloak, and a range of dreamy jewelry—you may have spotted some of it in Beyoncé's *Black Is King* visual album. The label is by Soull and Dynasty Ogun, whose deep connection is genetic: The two designers are identical twins. L'Enchanteur is the quintessential mix of their personalities and creative backgrounds. Soull is a self-taught metalsmith, while Dynasty works with textile design and tailoring. "You're able to reflect on ways that you want to see yourself or things you are missing in your blind spots," says Soull. The 37-year-old pair were raised in a creative and vibrant home, with their father—a chemist-engineer-cabdriver, well-heeled and dapper—a key inspiration, along with their mother, a seamstress from the West Indian island of Dominica. "[Our upbringing] really inspired the way that we look at the world," says Soull. "We design telling our story of growing up."

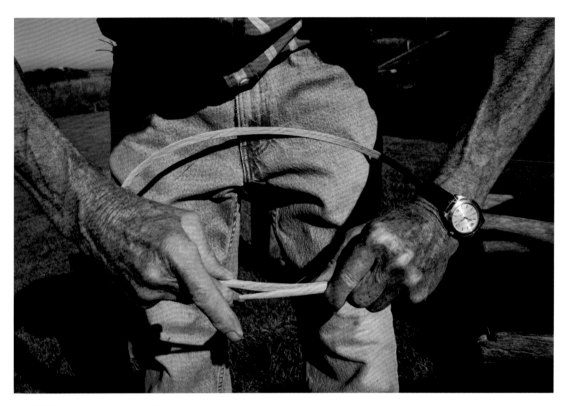

Karl Ottison, manipulating a length of rattan.

KARL AND SUSAN OTTISON, NANTUCKET, MASSACHUSETTS
Karl and Susan Ottison have been making baskets together since they were married in Nantucket in 1979. Susan credits her sister Nancy with teaching her the artistry behind the island's signature rattan style, while Karl takes care of the woodworking. (Each basket, which takes at least 40 meticulous hours to create, becomes an instant heirloom.) Carrying on their local tradition and sharing Nantucket's history with others—clients come from far and wide to commission the Ottisons, and their work has even landed in the White House—is what keeps the couple inspired. "Our work is a modern-day representation of a craft that began 160 years ago," Susan says.

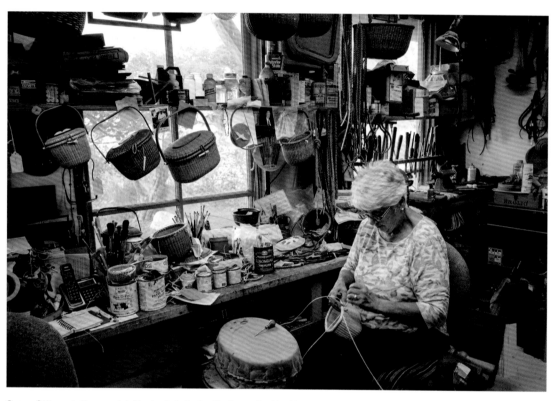

Susan Ottison, in the couple's Nantucket studio. Photographed by Alex Webb.

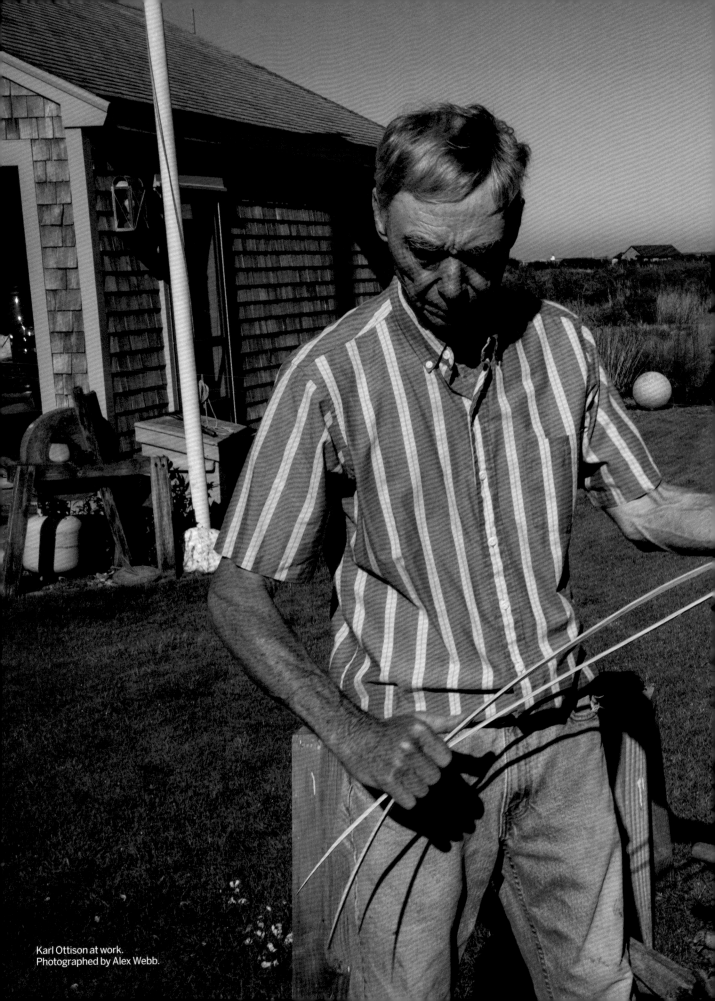

Karl Ottison at work.
Photographed by Alex Webb.

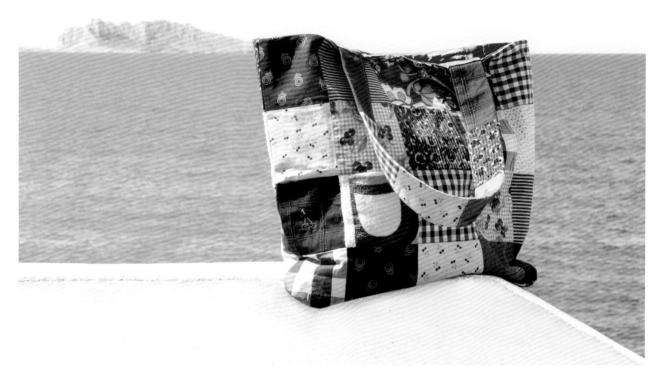

A patchworked bag by Asata Maisé. Photographed by Sarah-Leila Payan.

The designer, at home in Delaware. Photographed by Justine Kurland.

ASATA MAISÉ, WILMINGTON, DELAWARE
You need to be quick to get a piece from Delaware-based designer Asata Maisé. Each time she releases a collection of accessories and clothing, it sells out. The pieces certainly make for good eye candy: Both her bags and her curve-skimming dresses are patchworked from a mélange of colorful deadstock and vintage fabric. After a handful of years working for other designers and waiting tables in Los Angeles and New York, she decamped home to Delaware in 2019—and a recent look book was composed of local talent, including a photographer, a skater, and a fellow designer. "Creative people have to come together and collaborate," says Maisé. "That's how we create our own sense of community in our own hub."

DUR DOUX, WASHINGTON, D.C.

Founded in 2013 by mother-daughter duo Cynthia and Najla Burt in Washington, D.C., Dur Doux ("hard soft") brings an original avant-garde sensibility to everything it makes, from a pastel high-low tulle evening number to a teal minidress covered in rosettes. In a city not known for sartorial style, flair, or experimentation, the label's fanciful eveningwear makes a statement. Still, D.C.'s global perspective is key. "Instead of rooting our brand in the American fashion idea, we are totally rooted in the international," Cynthia says. A city like New York could also offer a global mindset—Dur Doux did make its Fashion Week debut there in September 2020—but D.C. also boasts space to create and historic architecture to inform the label's work.

ABOVE: Designers Najla and Cynthia Burt. OPPOSITE, FROM FAR LEFT: Model Selamawit Yirga, model Katherine Calvert, and influencer Anchyi Wei, all wearing Dur Doux. Photographed by Sabiha Çimen.

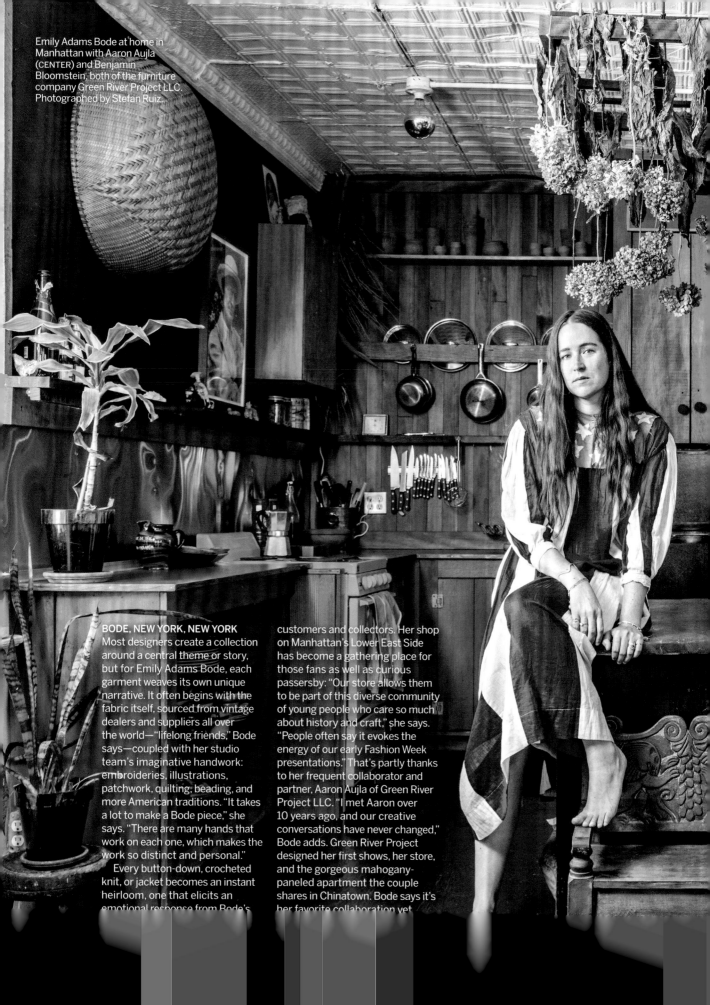

Emily Adams Bode at home in Manhattan with Aaron Aujla (CENTER) and Benjamin Bloomstein, both of the furniture company Green River Project LLC. Photographed by Stefan Ruiz.

BODE, NEW YORK, NEW YORK

Most designers create a collection around a central theme or story, but for Emily Adams Bode, each garment weaves its own unique narrative. It often begins with the fabric itself, sourced from vintage dealers and suppliers all over the world—"lifelong friends," Bode says—coupled with her studio team's imaginative handwork: embroideries, illustrations, patchwork, quilting, beading, and more American traditions. "It takes a lot to make a Bode piece," she says. "There are many hands that work on each one, which makes the work so distinct and personal."

Every button-down, crocheted knit, or jacket becomes an instant heirloom, one that elicits an emotional response from Bode's

customers and collectors. Her shop on Manhattan's Lower East Side has become a gathering place for those fans as well as curious passersby: "Our store allows them to be part of this diverse community of young people who care so much about history and craft," she says. "People often say it evokes the energy of our early Fashion Week presentations." That's partly thanks to her frequent collaborator and partner, Aaron Aujla of Green River Project LLC. "I met Aaron over 10 years ago, and our creative conversations have never changed," Bode adds. Green River Project designed her first shows, her store, and the gorgeous mahogany-paneled apartment the couple shares in Chinatown. Bode says it's her favorite collaboration yet

Model Toni Smith in a Hanifa dress.
Photographed by Daveed Baptiste.

HANIFA, KENSINGTON, MARYLAND
Since Anifa Mvuemba's nine-year-old brand went viral in June 2020 with a virtual show, she's been able to work from anywhere. Still, her hometown of Kensington is where she feels at ease. With her clothes now worn by Sarah Jessica Parker and featured in magazine editorials and music videos, Mvuemba wants to ensure that Black designers across the United States are afforded the same opportunities. "I'm just hoping I can help the next generation that's coming up," she says. "That's my biggest goal."

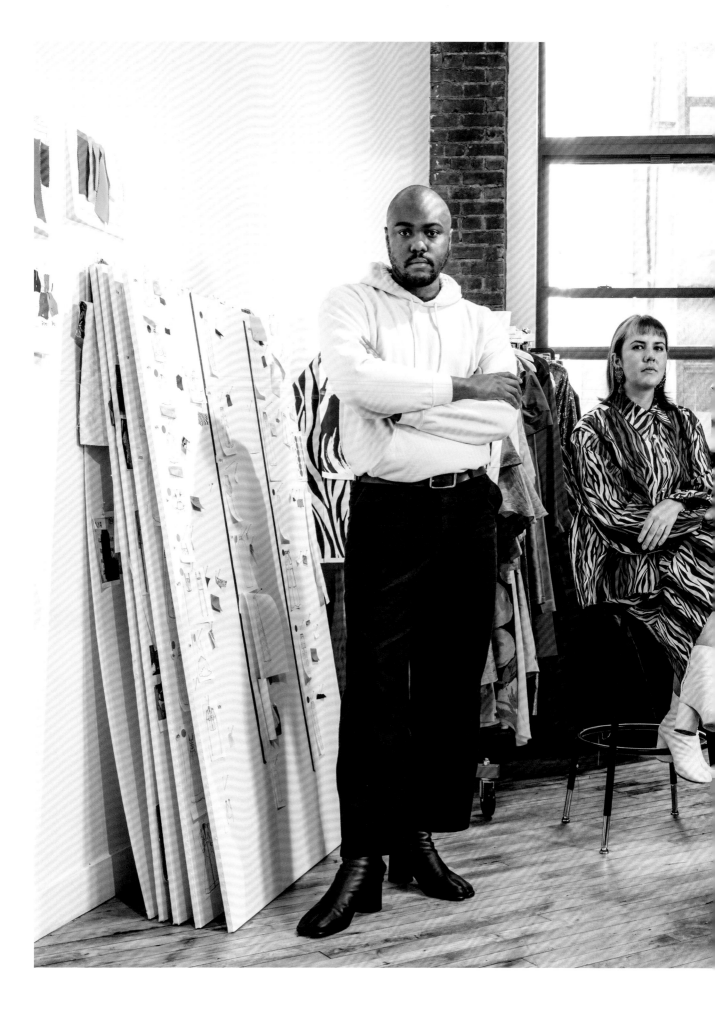

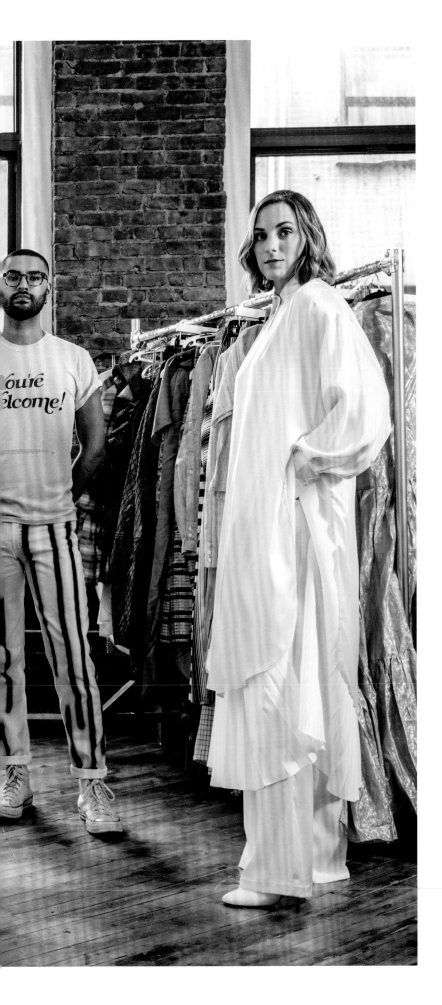

CHRISTOPHER JOHN ROGERS, BROOKLYN, NEW YORK

It isn't unusual for a designer to refer to his or her team as a family, but in Christopher John Rogers's case, it's more than an expression. He started his brand not just by working day in and day out with his team: He lived with them, too. They're the sewers, makers, and creatives who have been with Rogers since his first collection in 2018, and every garment that's graced his runway began in their shared living room in Bushwick. (They've now migrated to a studio in SoHo.) Their process is one of true collaboration, with clothes that tell a story of "soul, intention, and craft," Rogers says. "We don't always see eye to eye on everything, but we love each other regardless, and that manifests itself in the clothes," he adds. Even as the pandemic forced their close-knit group apart, Rogers credits his colleagues for keeping him focused and optimistic. "My team inspires me to dream bigger than I think is possible," he says. "They also remind me of who I am, how I've gotten to this point in my career, and how to stay grounded through everything. We're all just regular folks making clothes to help you feel extraordinary."

FROM FAR LEFT: The designer, with production director Alexandra Tyson, studio director David Rivera, and brand director Christina Ripley. Photographed by Stefan Ruiz.

Saudia Islam, in a skirt of her own design.
Photographed by Hannah Price.

JBD APPAREL, PHILADELPHIA, PENNSYLVANIA
Saudia Islam's Philadelphia-based knitwear company JBD Apparel had its big break when Kim Kardashian West wore and posted a blush-pink, body-hugging, midriff-baring "going out" knit set in June 2020. The designer—also a mother to a one-year-old—started a crochet club in middle school and began knitting as a way to release stress. Since Islam launched her label in 2017, those slinky, curve-skimming skirts, corsets, and off-the-shoulder tops are in red-hot demand. And while the designer has entertained the notion of relocating to New York, Philadelphia seems to suit both her career and her life. "It's more valuable for me to stay here because of the family dynamic that I have," she says. "It's my support system. The pandemic made me realize that I'm able to run a business in a place that I want to run a business from."

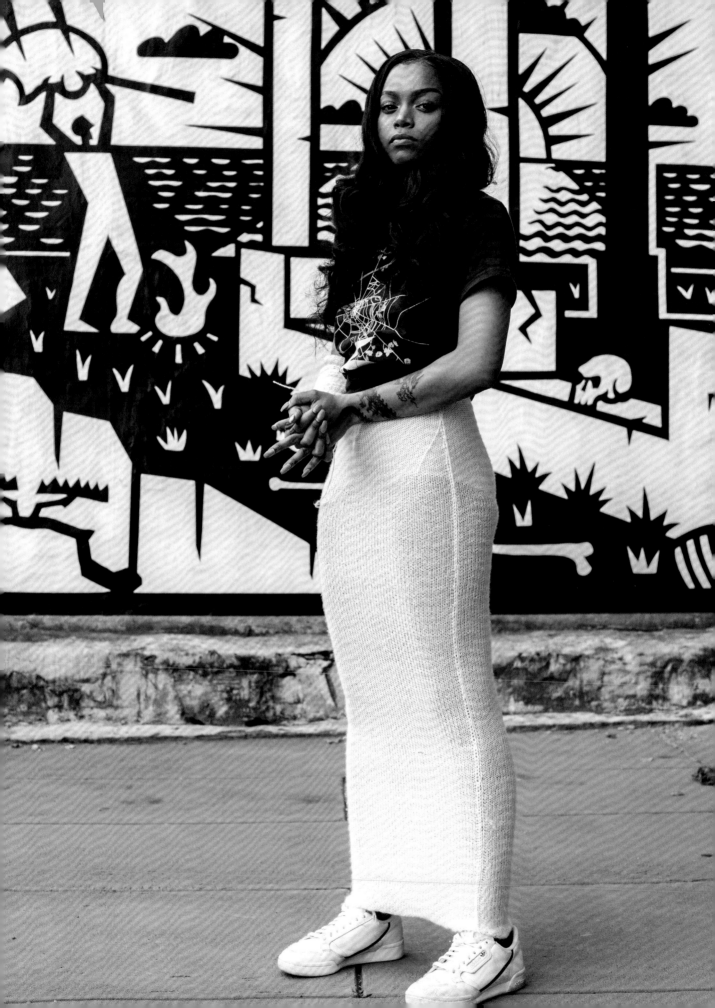

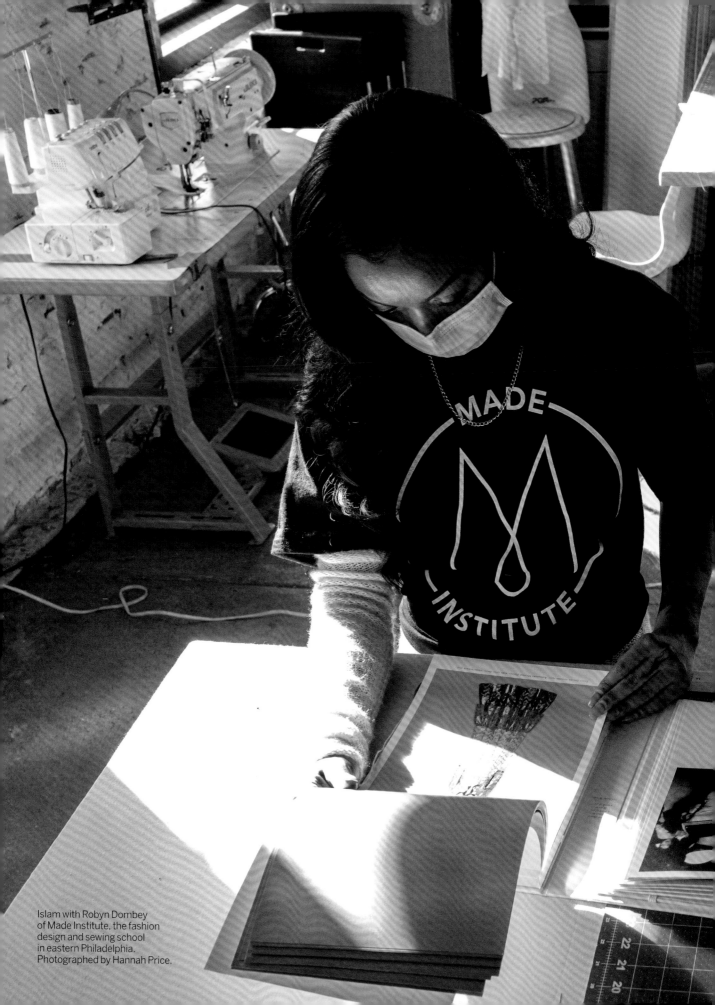

Islam with Robyn Dombey
of Made Institute, the fashion
design and sewing school
in eastern Philadelphia.
Photographed by Hannah Price.

THE MID-WEST

IN CHICAGO, MINNEAPOLIS, Detroit, and other Midwestern cities, a distinctive fashion vision has emerged: one that marries vibrance and practicality, accessibility and glamour. For creatives like Azeeza Khan and Marion Parke, distance from the flash and dash of the coasts has been key, allowing them the time and space to create. Not to be overlooked, though: the welcome wagon rolled out by locals, even within their fledgling design communities. Of the growing fashion scene in Indianapolis, Union Western Clothing's Jerry Lee Atwood says: "It's been really amazing to see a community so genuinely invested in seeing other people succeed."

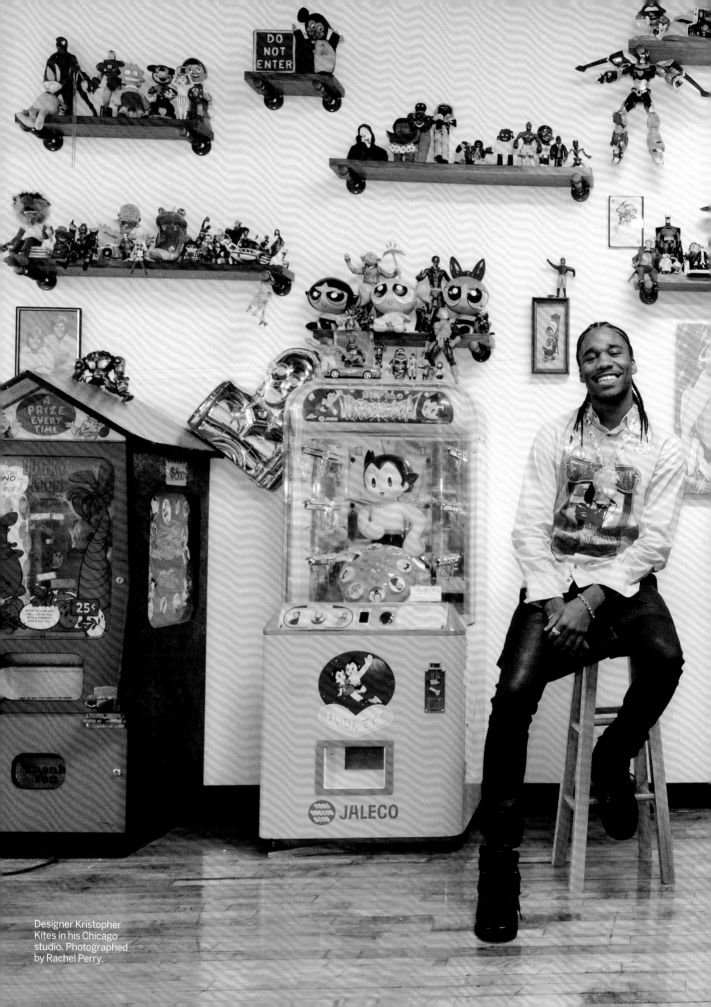

Designer Kristopher Kites in his Chicago studio. Photographed by Rachel Perry.

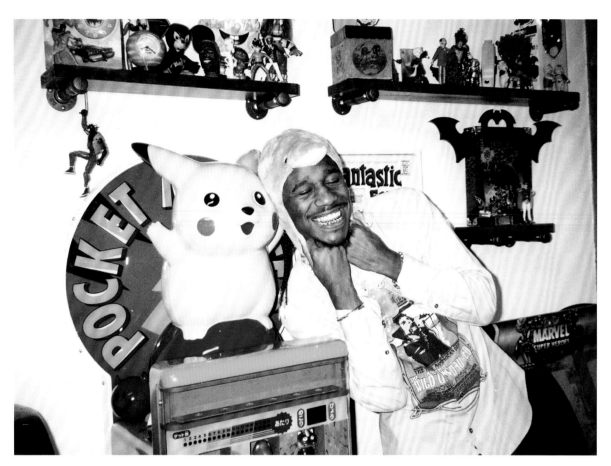

ABOVE: The designer. OPPOSITE: Necklaces, a rug, and other objects designed by Kites.
Photographed by Rachel Perry.

KRISTOPHER KITES, CHICAGO, ILLINOIS
Since 2018, Kristopher Kites has been making playful plastic pendants out of comic-book figurines, transforming his childhood obsessions into wearable works of art. "Watching old cartoons, I was like, Wow, this gives me an emotional feeling of feeling good, but how can I make that physical?" he explains. Lately, the South Side native has added home goods to his repertoire and become the inaugural designer in residence at RSVP Gallery, the cult-favorite Chicago boutique cofounded by Don C and Virgil Abloh; but more is still to come. "I design clothes and different jewelry pieces, but I'm also working on music, and I want to act," Kites says. "I just think of myself as a creative."

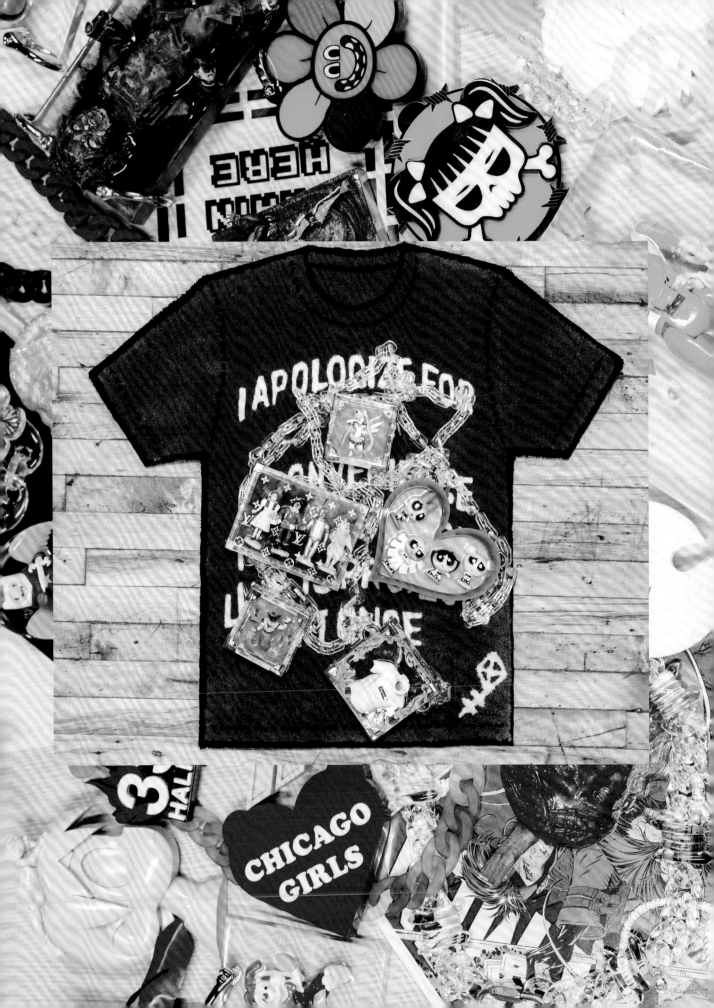

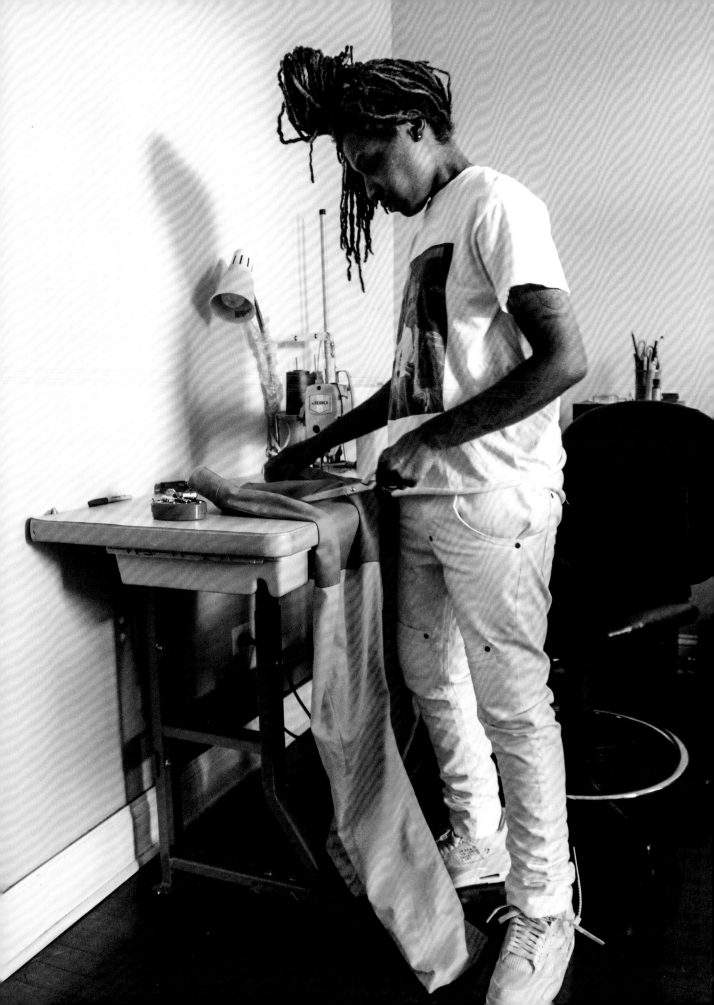

SHEILA RASHID, CHICAGO, ILLINOIS

When Chance the Rapper wore Sheila Rashid's signature denim overalls to the VMAs in 2016, he instantly put her self-titled fashion label on the map. Much like the music of the Chicago hip-hop artist, Rashid's custom workwear pieces reflect the down-to-earth swagger of the Windy City. "Living here, you really need clothes that look and feel good; but more than that, they need to stand up to the elements," she says. The designer grew up on the South Side of the city and understands the transformative power of community. "A lot of us work independently—we share the resources we have with our peers. In fact, supporting each other is what we live for."

TOP: Pants by Rashid, in colors inspired by the Chicago Transit Authority's train lines. ABOVE: Flowers in the designer's neighborhood. OPPOSITE: The designer, at work on a recent collection. Photographed by Sheila Rashid.

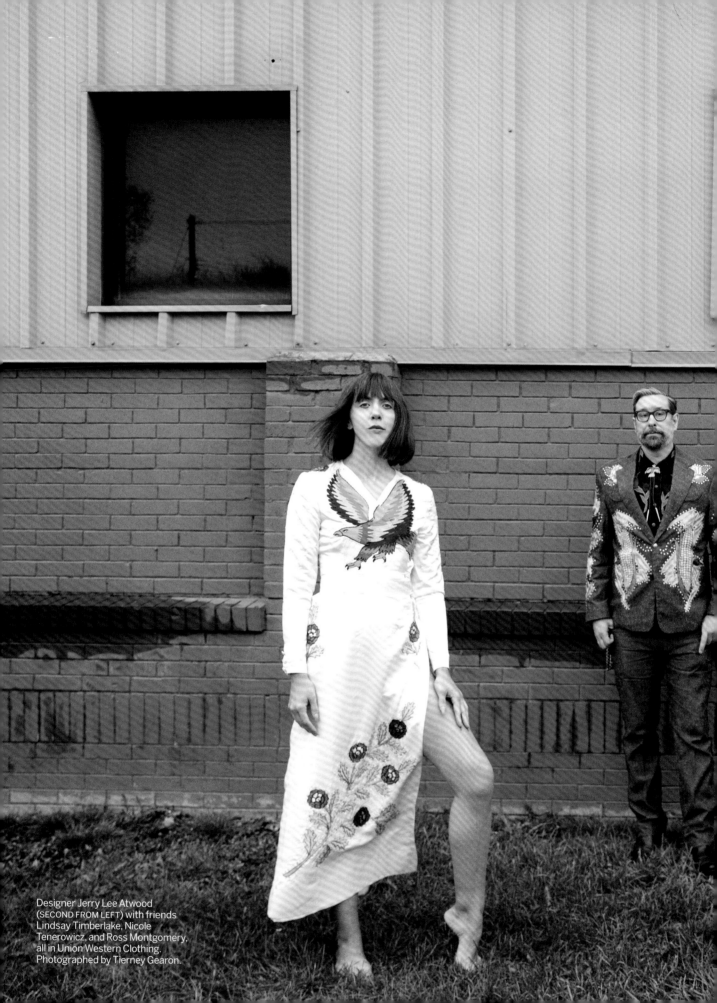

Designer Jerry Lee Atwood
(SECOND FROM LEFT) with friends
Lindsay Timberlake, Nicole
Tenerowicz, and Ross Montgomery,
all in Union Western Clothing.
Photographed by Tierney Gearon.

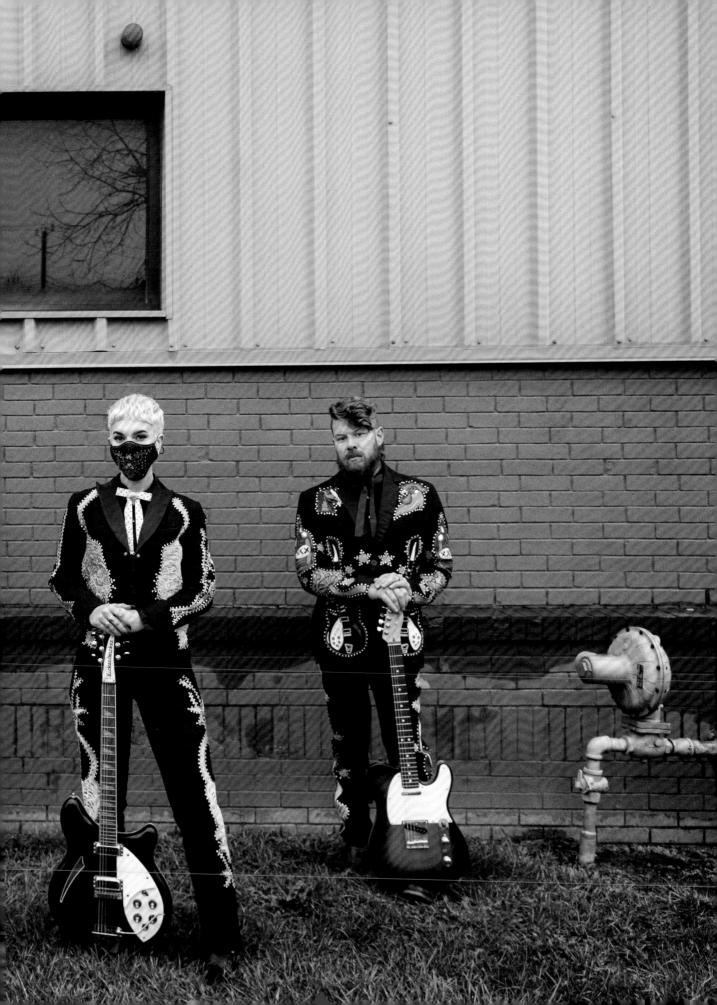

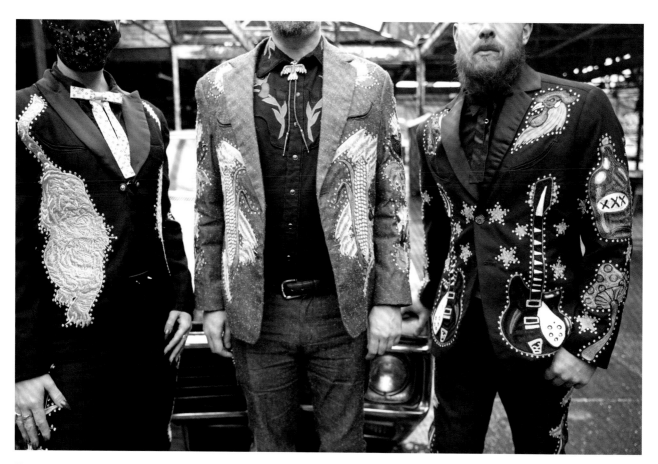

Tenerowicz, Atwood, and Montgomery.

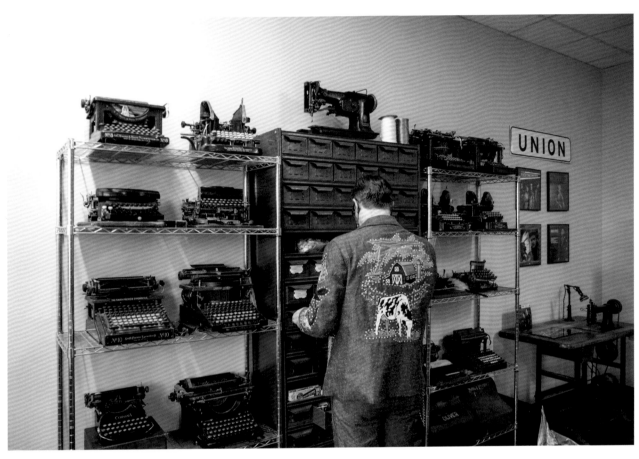

Inside Union Western Clothing's studio space. Photographed by Tierney Gearon.

UNION WESTERN CLOTHING, INDIANAPOLIS, INDIANA

Few garments are quite as American as the Nudie Suit, the bedazzled and bejeweled ensemble popularized by tailor Nudie Cohn in the late '50s and '60s—and worn, most famously, by Elvis. It's only fitting, then, that Nudie's legacy is being carried on in the heart of the Midwest, where tailor Jerry Lee Atwood (and his London-based partner Joe David Walters) whips up custom interpretations of the embellished suits for 21st-century artists like Post Malone,

Lil Nas X, and Orville Peck. "When you tell someone in Indianapolis that you're a fashion designer, the first question they usually ask is, 'Are you visiting?' " Atwood says. "There wasn't a lot of infrastructure here to support fashion— that's changing, thanks to a lot of hard work from people in the community." Social media has been a boon, but as the business grows, Union Western expects to stay put. "It's been really amazing to see a community so genuinely invested in seeing other people succeed," Atwood says.

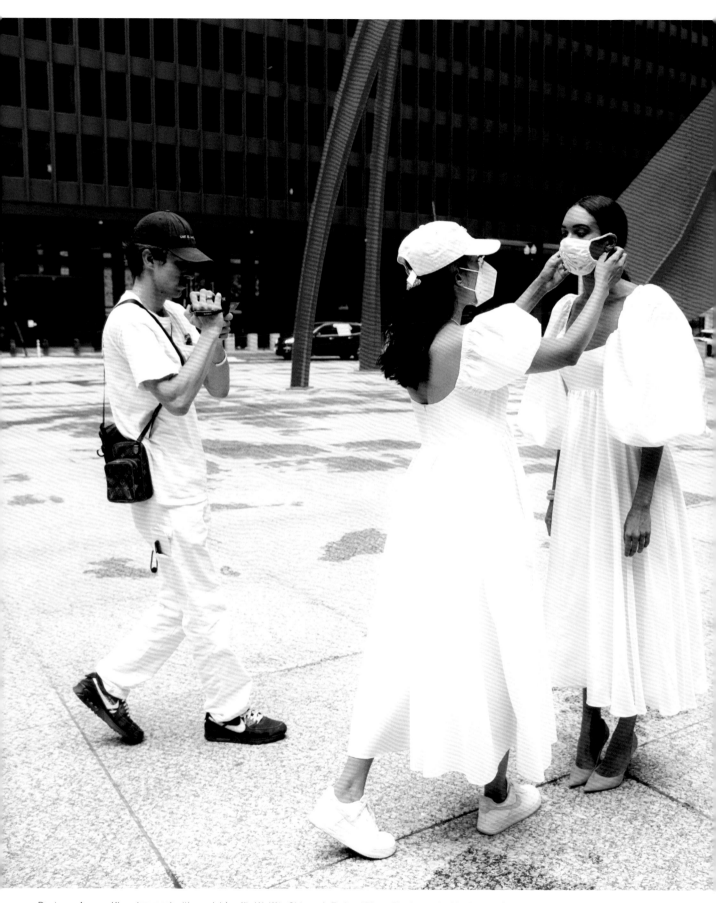

Designer Azeeza Khan (CENTER) with model Aurélie Wulff in Chicago's Federal Plaza. Photographed by Bianca Garcia.

AZEEZA, CHICAGO, ILLINOIS

For lifelong Chicagoan Azeeza Khan, her city is at the heart of everything she does. "My grandmother gave her entire savings so my father could leave India to come here to live the American dream," she says, "so we very consciously chose to keep our base camp here." A former oil-company marketing exec, Khan originally thought of fashion as more of a side hustle—but when she saw the reaction her colorful, feminine, and universally flattering dresses were getting, she realized she was onto something. The youthful glamour of Khan's self-titled label (founded in 2011) vibes with Wicker Park and West Loop, but it's also resonated with Hollywood fans like Jennifer Lopez, Beyoncé, and Barbra Streisand. "There's a lot of noise in this industry," Khan says. "Chicago let me be myself—I could just focus on making great work."

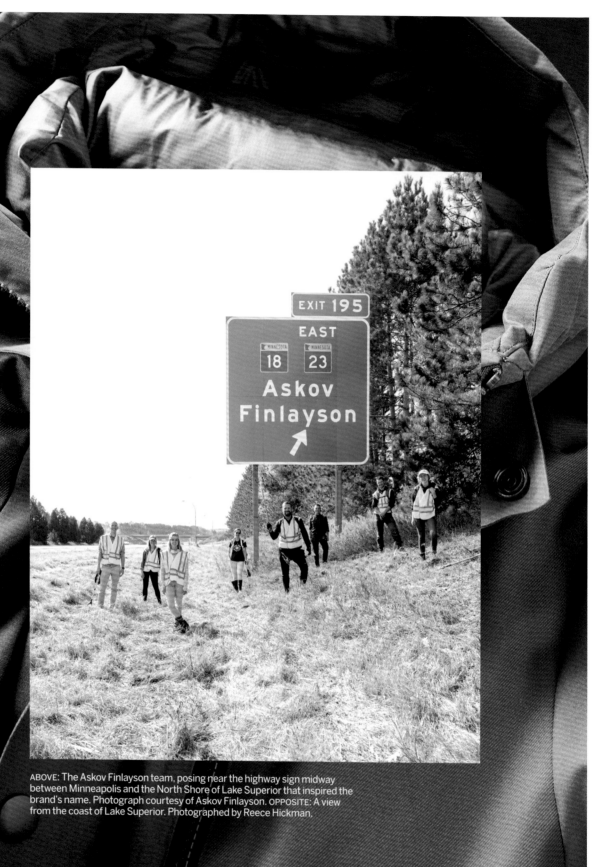

ABOVE: The Askov Finlayson team, posing near the highway sign midway between Minneapolis and the North Shore of Lake Superior that inspired the brand's name. Photograph courtesy of Askov Finlayson. OPPOSITE: A view from the coast of Lake Superior. Photographed by Reece Hickman.

ASKOV FINLAYSON,
MINNEAPOLIS, MINNESOTA

Askov Finlayson specializes in outerwear, so it's no surprise that Eric Dayton, its CEO and cofounder, has long been immersed in nature. "Spending time outdoors is a very important part of the lifestyle here, and that's year-round," says Dayton, who grew up in Minneapolis and spent his summers canoeing and camping by the Boundary Waters or taking day trips to the northern shore of Lake Superior. "What we make is completely rooted in this place." Today, his label is rooted in eco-consciousness as a result: All of his pieces are climate-positive, meaning the production goes beyond zero-carbon emissions. "Instead of sustainability, I prefer the idea of accountability—taking accountability for our footprint and offsetting it by 110 percent," he says. "We have a limited amount of time to fix this—and the consequences if we fail are catastrophic."

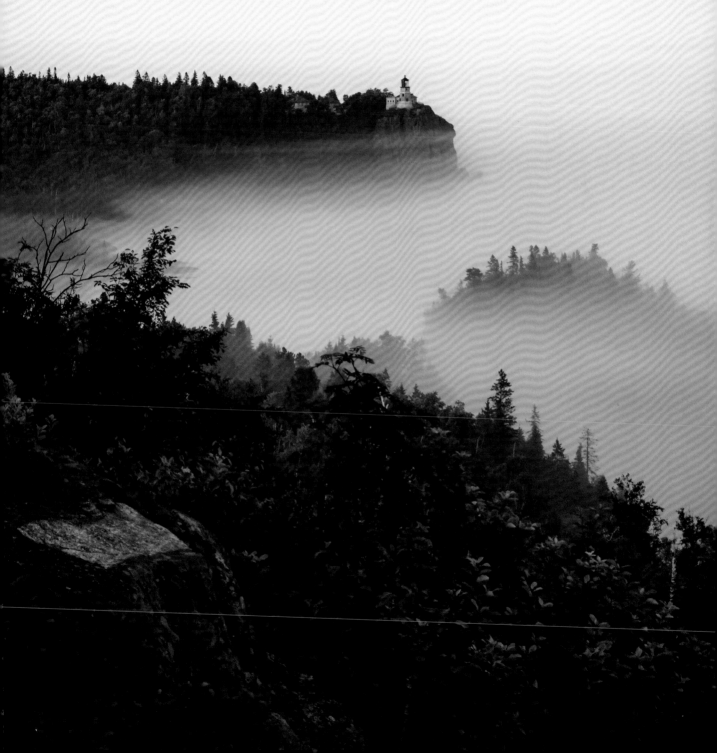

HOPE FOR FLOWERS, DETROIT, MICHIGAN

The myth of constant growth and "bigger is better" never sat quite right with Tracy Reese. In 2019, she chose to step away from her self-titled brand in New York, a global business more than two decades in the making. In its place, she launched Hope for Flowers, a much smaller outfit focused on sustainability, inclusivity, and community—values that have only become more important since then. Now based in her hometown of Detroit, Reese says her biggest goal is to foster a local fashion industry and train people in design, manufacturing, and all facets of operations. "Anything I could do in New York, I can do in Detroit," she insists. "There are so many amazing artists and craftspeople here—and we all know that we will succeed if we work together."

FROM FAR LEFT: Roslyn Karamoko, Katherine Johnson, Hannah Morris, Jourdan Sims, and Erin Reese-Burks—all friends and relations of the brand—in Tracy Reese's designs at the Museum of Contemporary Art Detroit. Photographed by Christina Holmes.

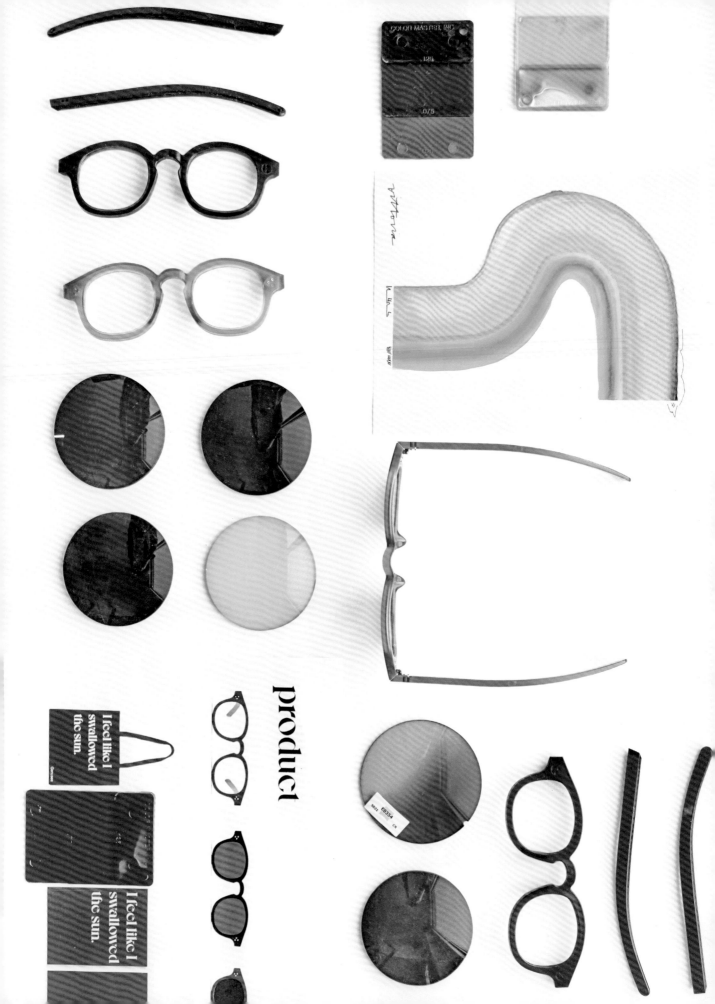

product

I feel like I swallowed the sun.

I feel like I swallowed the sun.

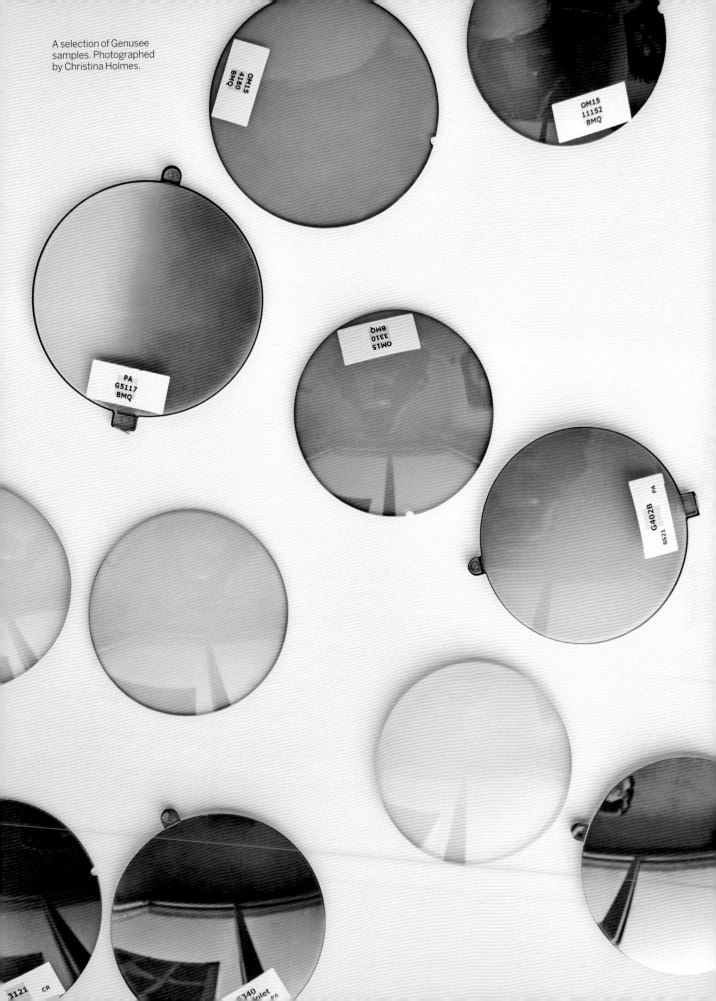

A selection of Genusee samples. Photographed by Christina Holmes.

OM15
4180
BMQ

OM15
11152
BMQ

PA
G5117
BMQ

OM15
0TEE
BW8

G402B PA

SS21

3121 CR

5340 PA
olet

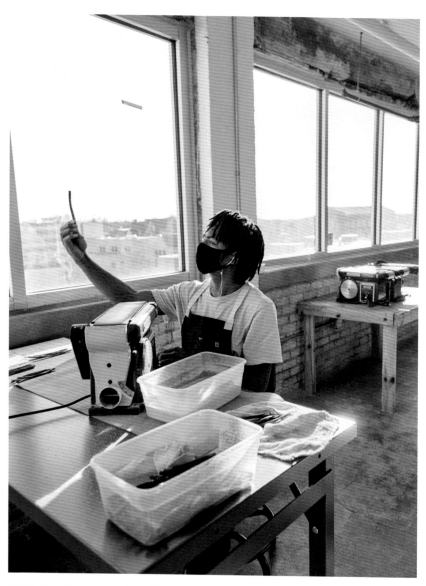

ABOVE: Omar Young, a member of Genusee's assembly team. OPPOSITE: Ali Rose VanOverbeke, the brand's founder. Photographed by Christina Holmes.

GENUSEE, FLINT, MICHIGAN

In 2015, the city of Flint, Michigan, was going through millions of single-use water bottles per day. It was a Band-Aid solution to a water crisis that had already left 100,000 people without clean water, but it created its own disaster: mountains of plastic waste. "It was the perfect example of environmental racism and injustice," says Ali Rose VanOverbeke, a former New York designer and Michigan native. She saw an opportunity to clean up Flint, create new jobs, and support the circular economy with Genusee, a line of eyewear made from those recycled plastic containers. After a few years of building the brand, she relocated to Flint full-time in 2018. "I've never met a more resilient group of people who persevere despite the circumstances," she says. "I wanted to be a part of that energy and work ethic."

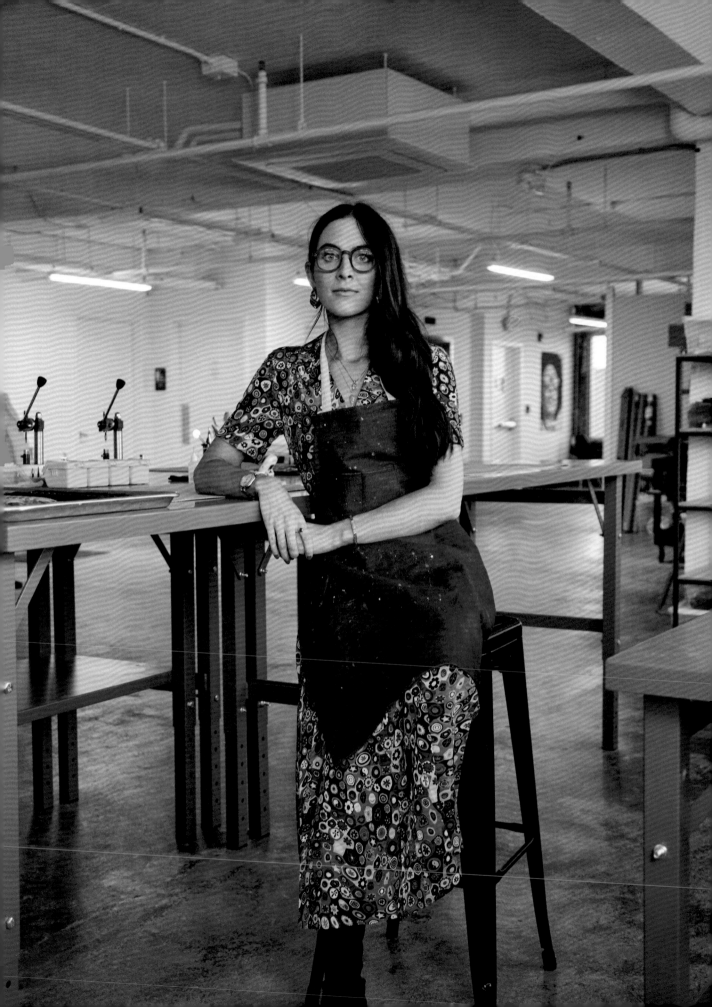

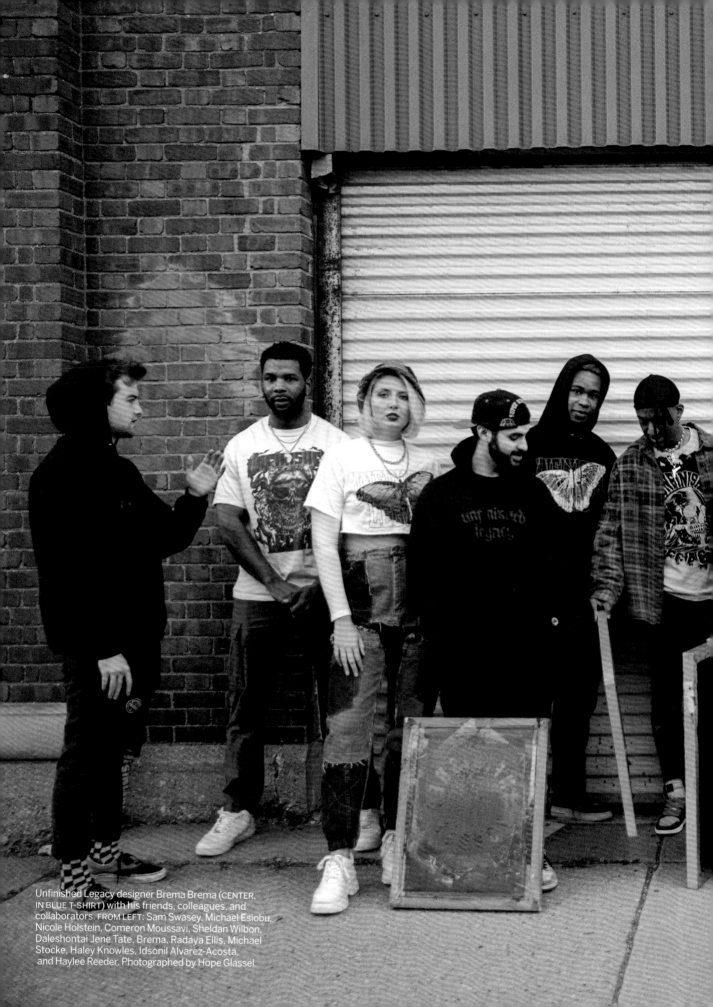

Unfinished Legacy designer Brema Brema (CENTER, IN BLUE T-SHIRT) with his friends, colleagues, and collaborators. FROM LEFT: Sam Swasey, Michael Esiobu, Nicole Holstein, Comeron Moussavi, Sheldan Wilbon, Daleshontai Jene Tate, Brema, Radaya Ellis, Michael Stocke, Haley Knowles, Idsonil Alvarez-Acosta, and Haylee Reeder. Photographed by Hope Glassel.

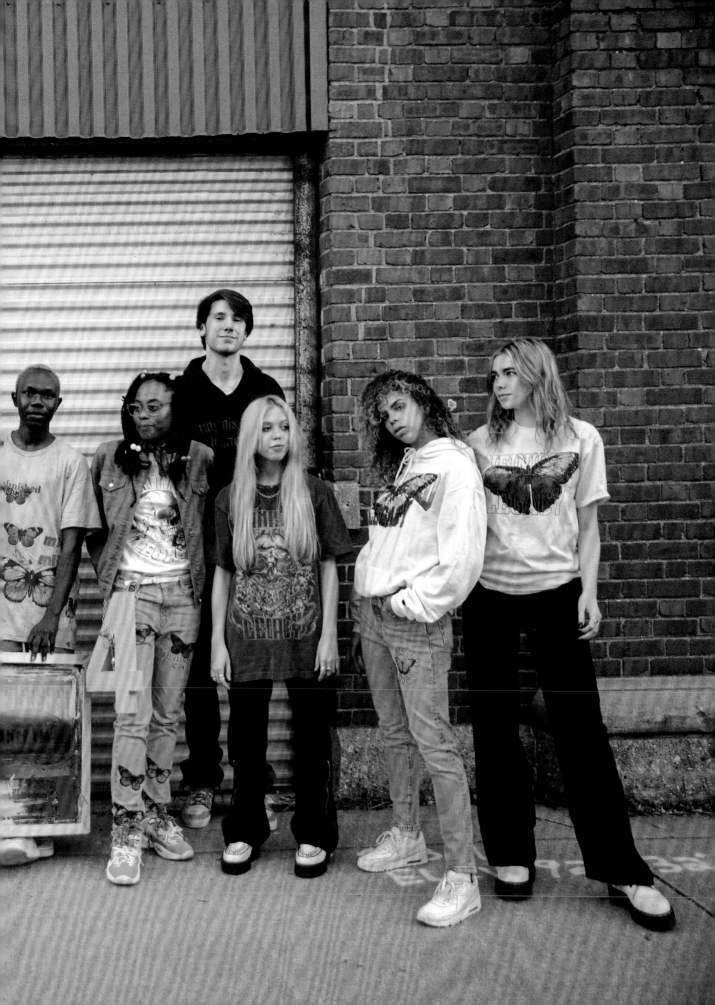

UNFINISHED LEGACY, MILWAUKEE, WISCONSIN

Brema Brema was born in Sudan during that country's civil war and lived there until his family fled to a Kenyan refugee camp, and later the United States. In high school, he launched Unfinished Legacy, his label of screen-printed denim, hoodies, and tees. Today, Brema's brand uses such symbolism as hopeful butterflies and Black Lives Matter signage in an effort to inspire his generation to keep moving forward. Recently, he did a small collaboration with Levi's. Next up: incorporating more sustainable practices—and spearheading community programs. "It's not just about putting a design on a hoodie," Brema says. "It's about contributing to the world in a positive way."

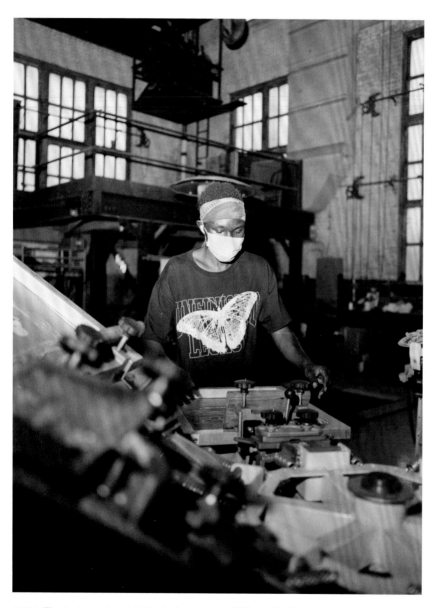

ABOVE: The designer at work in his studio. OPPOSITE: With a rack of his signature screen-printed hoodies. Photographed by Michael Stocke.

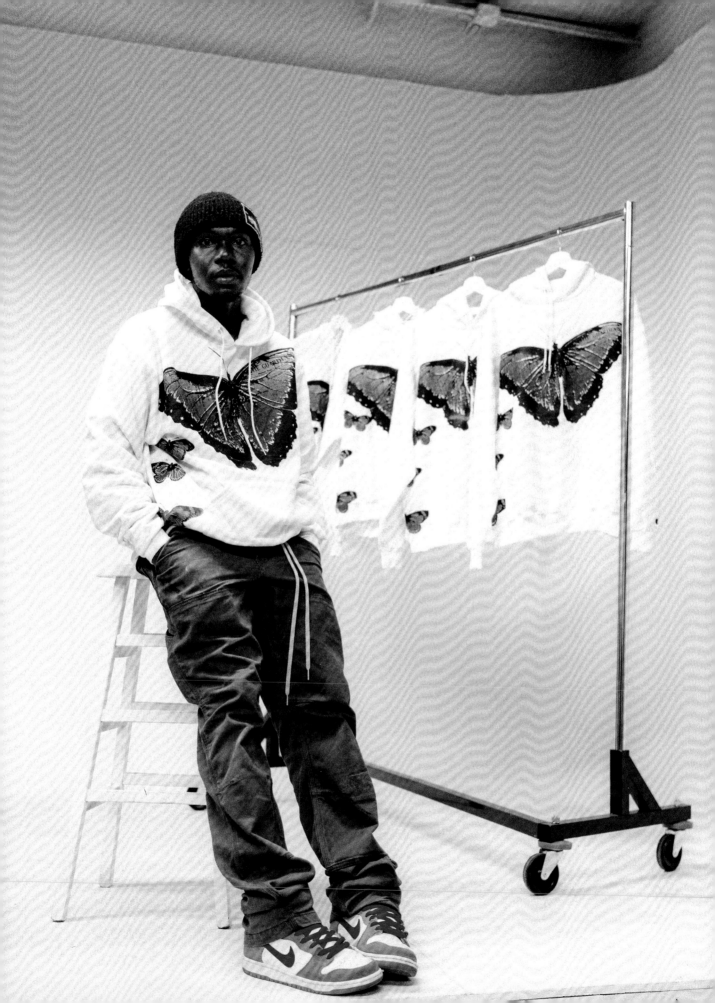

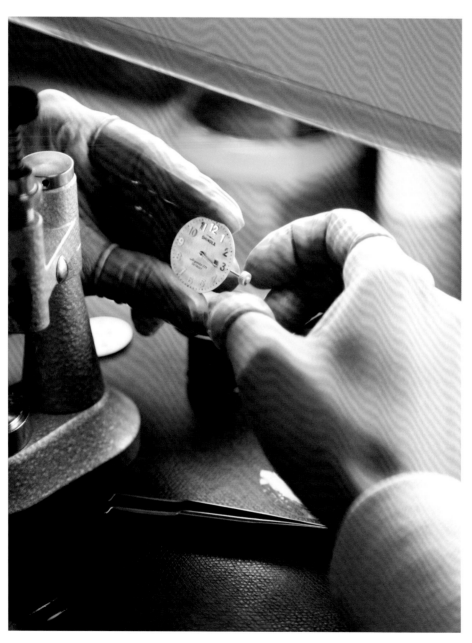

FROM LEFT: The making of a Shinola watch; the view from the brand's flagship store in Detroit; Manuel Villareal, a movement/watch assembler (and aspiring repair technician). Photographed by Christina Holmes.

SHINOLA, DETROIT, MICHIGAN

Detroit's manufacturing roots provide endless inspiration for Shinola. The epicenter of the brand is the 12,000-square-foot factory in the Motor City, which opened in 2012, where watches—a key component of the brand—are hand-assembled, with more than 30 people building each one, and where leather straps are cut, sewn, and painted.

But it would be hard to define Shinola as merely a watch brand. "If it's made, we want to try to make it better," says Trish O'Callaghan, Shinola's vice president of communications. In addition to watches, clocks, and leather goods, Shinola offers retro-looking bicycles, turntables, and jewelry. They even operate a boutique hotel in Detroit—one with an industrial aesthetic that mirrors the label's goods.

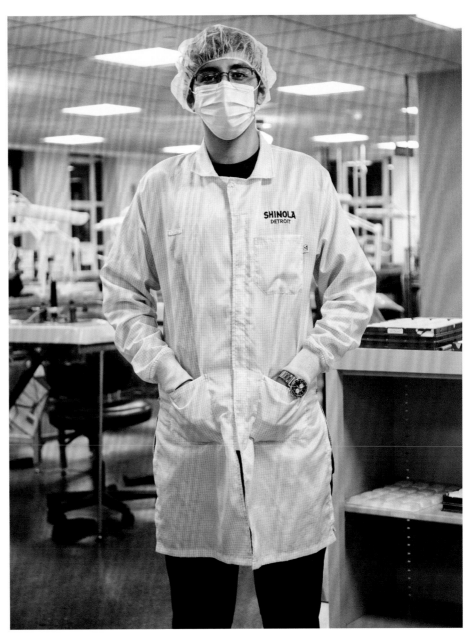

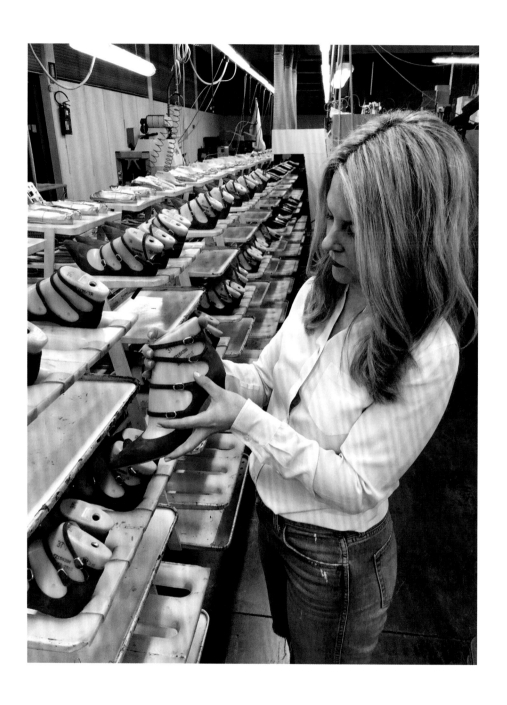

ABOVE AND OPPOSITE: Inside the designer's production process. Photographed by Liz Banfield.

MARION PARKE, MINNEAPOLIS, MINNESOTA

Inspiration strikes when we least expect it. For podiatrist turned footwear designer Marion Parke, the epiphany occurred during a 2006 biomechanics class. While studying the medical difficulties experienced by patients with naturally high arches, Parke noticed a correlation between their issues and those stiletto wearers face. "It was a true revelatory moment," says Parke. "I asked myself, Why don't we take some of the techniques we use to help people and apply them to a woman's high heel?"

It would take 10 years for Parke to turn her ambitious concept into a reality. In the interim, she practiced as a podiatrist while hitting the books to ensure her fashion—and footwear—education was as comprehensive as her medical one.

Finally, crediting muses from Kate Moss to her artsy grandmother, Parke set out to make chic shoes that used medical-grade materials. The balance between professional achievement and personal fulfillment resonates deeply. "Working in Minneapolis means that my husband and I can both pursue our goals, and we can raise our family with plenty of outdoor space, less traffic, and a slower pace," she says. "When we're meeting new buyers, they're often surprised we're not based in New York—but the product is so good, our story is authentic, and where we operate doesn't pose as much of an inconvenience as it might have 10 or 20 years ago." In short: The city that gave the world Lizzo, Prince, and Charlie Brown is the only place Parke would want to be.

THE SOUTH

WHAT DOES SOUTHERN style look like now? The answer depends on where you look. While some brands are shaped by familial ties—in Atlanta, Alissa Bertrand sews the most enchanting and colorful get-ups for her three young daughters, and in Texas, sisters Lizzie Means Duplantis and Sarah Means are dressing up the tried-and-true cowboy boot—others rely on the land for inspiration: In Florence, Alabama, Natalie Chanin crafts the pieces in her pared-back collection from locally grown crops. Others still, like Billy Reid's Alabama-based label, are out to bridge the gap between the old South and the new. "We seek to instill warmth in everything we do," Reid says.

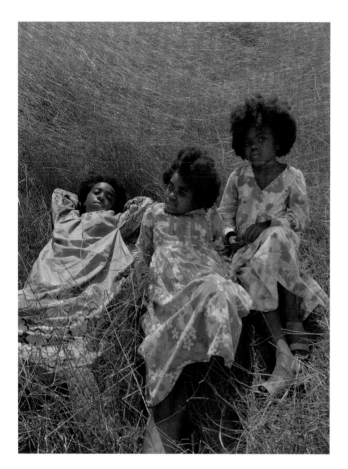
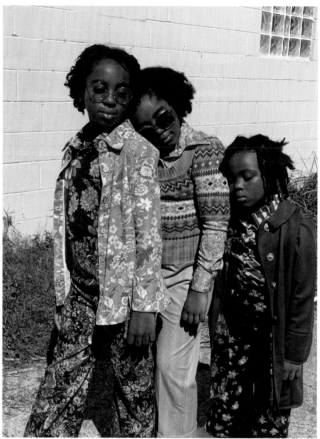

JABELLA FLEUR, ATLANTA, GEORGIA
Atlanta-based designer Alissa Bertrand has been sewing for more than 20 years, but it was only last year that she began to make clothes for her three daughters. "I couldn't afford what I wanted," she says. "So I started to create them myself." Ever since, Bertrand has been using upcycled materials from thrift stores for her bright, retro-inspired floral frocks and separates with ruffled collars and sleeves and prairie silhouettes while asking her kids to model them on Instagram. (She's designing a full children's line.) "We work together and talk about what they like," Bertrand says. "They each have a style of their own, and I try to follow that. We don't call this dressing up—it's just our look."

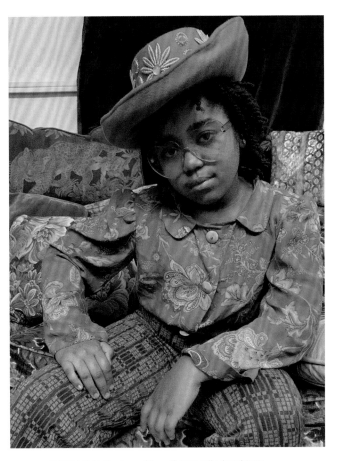
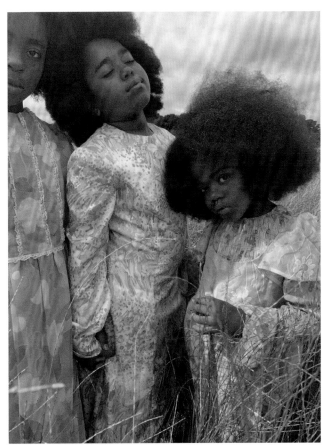

ABOVE AND OPPOSITE: Designer Alissa Bertrand's daughters, wearing Jabella Fleur. Photographed by Alissa Bertrand.

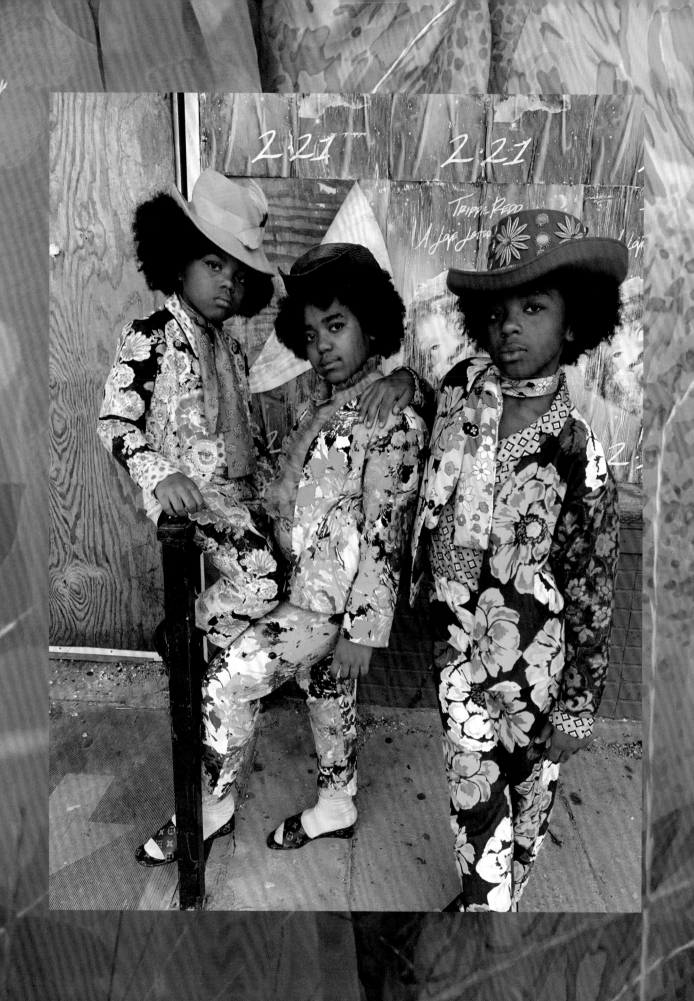

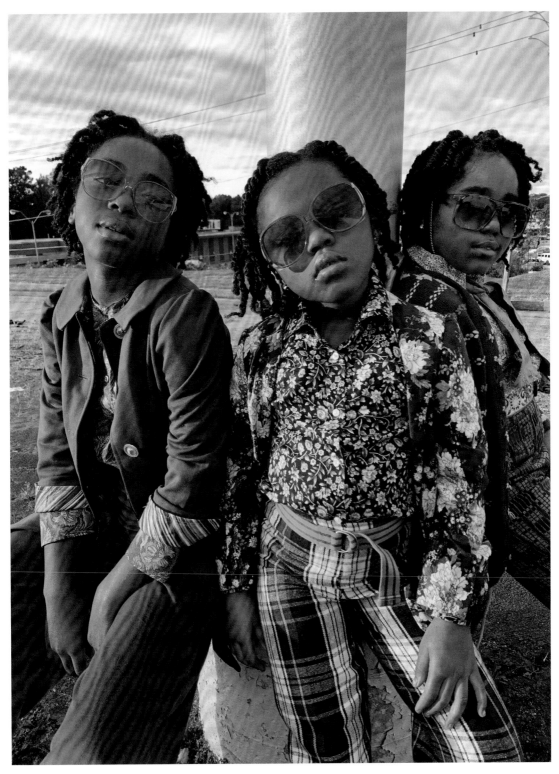

ABOVE, FROM LEFT: Jayla, Ella, and Jada Bertrand, all in their mother's joyful, upcycled designs. Photographed by Alissa Bertrand.

LUCCHESE, EL PASO, TEXAS

El Paso is a one-boot kind of town—
specifically, Lucchese, founded in San
Antonio nearly 140 years ago by the
immigrant Lucchese brothers, from Sicily.
A pair of boots can take 130 steps and six
weeks to make, passing through the hands
of as many as 300 craftspeople in the
process—yet in the end, their appeal comes
down to a single thing: the evocation of
the myth of Texas's sprawling landscape of
dude ranches and homesteads. "Lucchese
is a beautiful story of the American dream,"
says Trey Gilmore, the brand's director
of product development. "We have always
done truly functional wearable art—and
we still stand by that today."

A Western boot by Lucchese.
Photographed by Eli Durst.

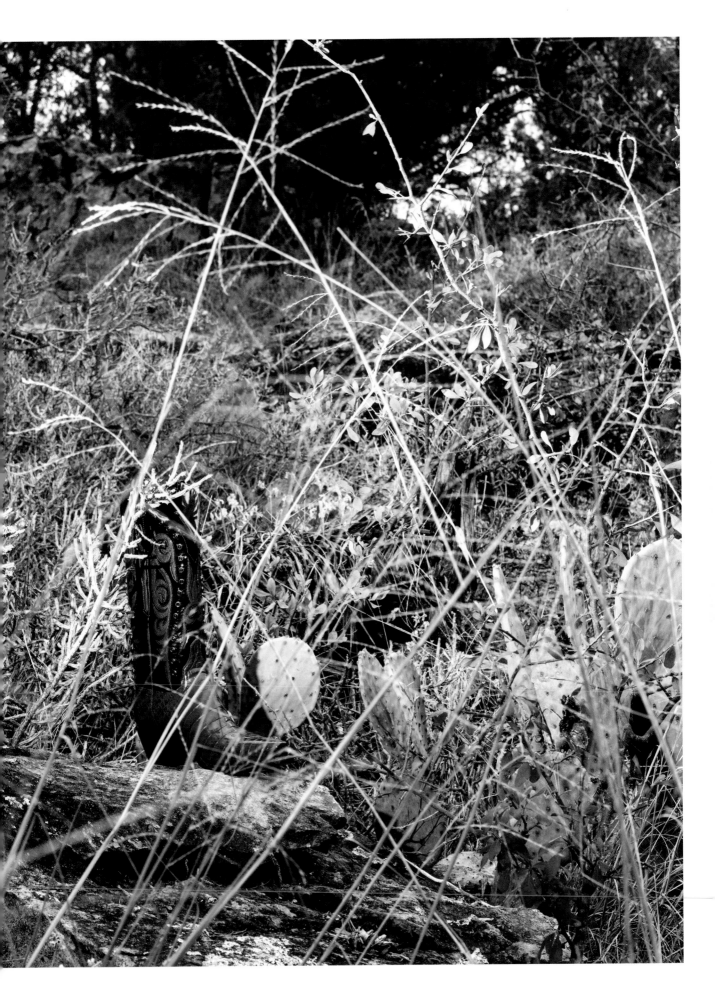

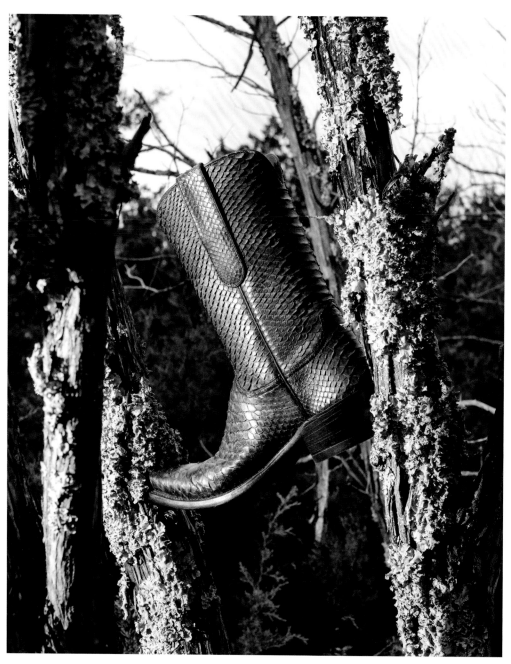

A Lucchese boot in ombre python.

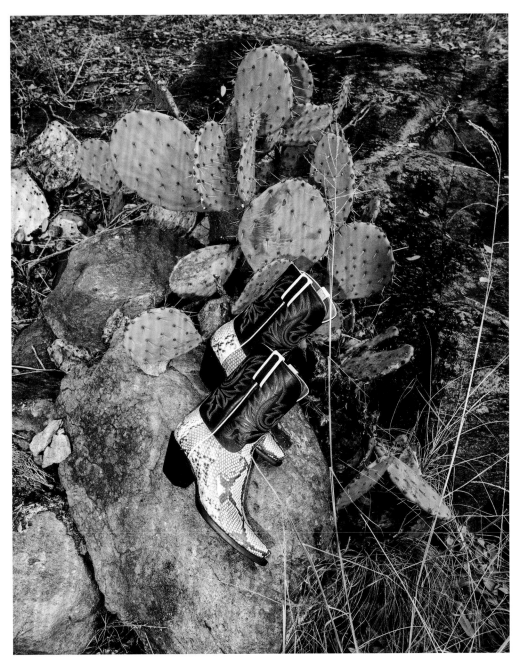

A style fashioned from goat leather and python. Photographed by Eli Durst.

ABOVE: The designer, at Trowbridge's Ice Cream Bar in Florence.
OPPOSITE: Fabric samples in Reid's studio. Photographed by Mark Steinmetz.

BILLY REID, FLORENCE, ALABAMA
Billy Reid has always designed from a personal point of view. Originally, that vision was expressed sartorially through cut and materials, but everything changed when Reid, who shuttered his business in New York after 9/11, jumped back into the game from Florence, Alabama, in 2004. Having put down deep roots himself, he has made place an essential part of the brand identity. "We are a modern Southern studio that we hope models a new South," says Reid, who was born in Louisiana. "We seek to instill warmth in everything we do."

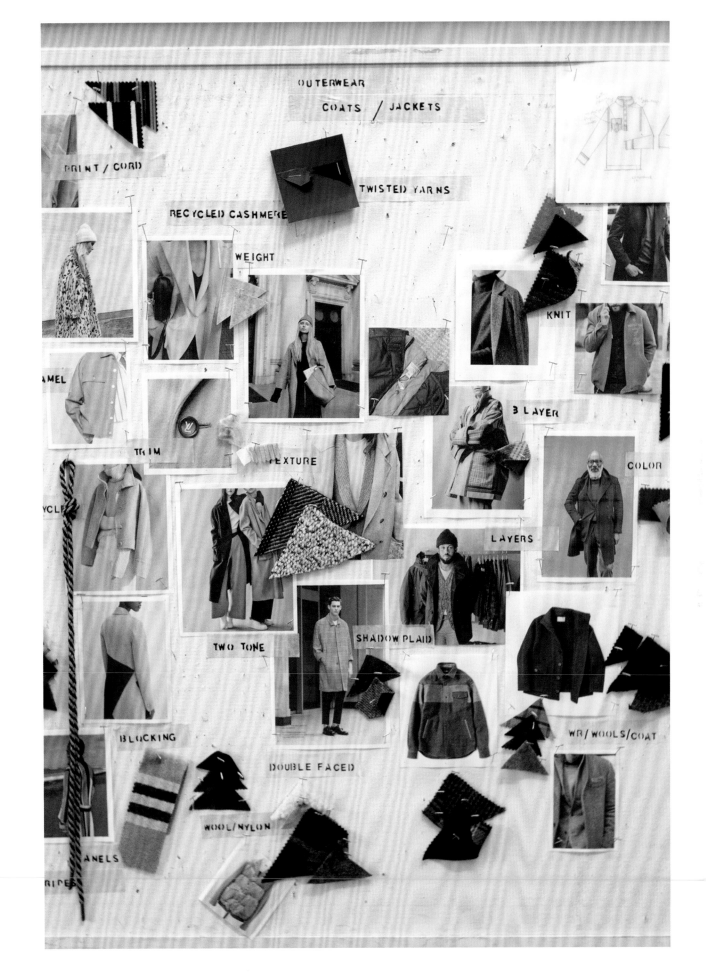

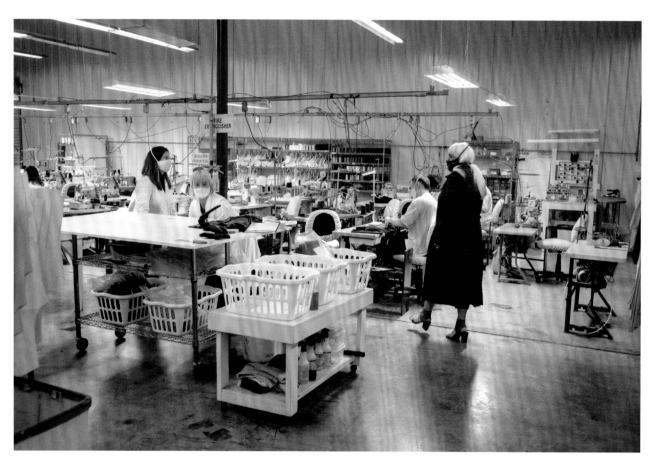

Inside Alabama Chanin's Factory Store in Florence.

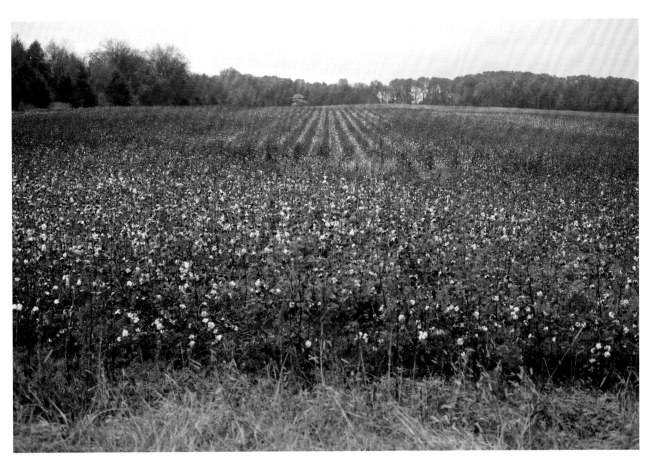

A cotton field near Florence. Photographed by Mark Steinmetz.

ALABAMA CHANIN, FLORENCE, ALABAMA
In 2000, Natalie Chanin returned home to Florence, Alabama, to reconnect with her roots and the hand-makers there for what was to be a one-off project. She never left. "Big magic" is how the designer describes the coming together of her brand, which is now recognized as a case study in how to do slow fashion responsibly and right. It was a process that, Chanin says, was like "being led down a road wildly." And while the pace has become a bit more manageable over time, Chanin's commitment—to land and hand, community and history—remains deep and strong. So does her belief in the freedom that comes from deciding how, and where, to work.

MATEO, HOUSTON, TEXAS

Matthew Harris, the Jamaican-born, Houston-based designer of Mateo, founded his line—titled after his nickname as a young model—in 2009. A decade or so later, his minimalist pieces, dotted with pearls and rife with references to modern art, are immediately recognizable. Harris's goal has always been to create fine jewelry at affordable-luxury prices. "I make pieces that, yes, you can dream a little about," he says, "but while you're dreaming, you should be wearing the dream."

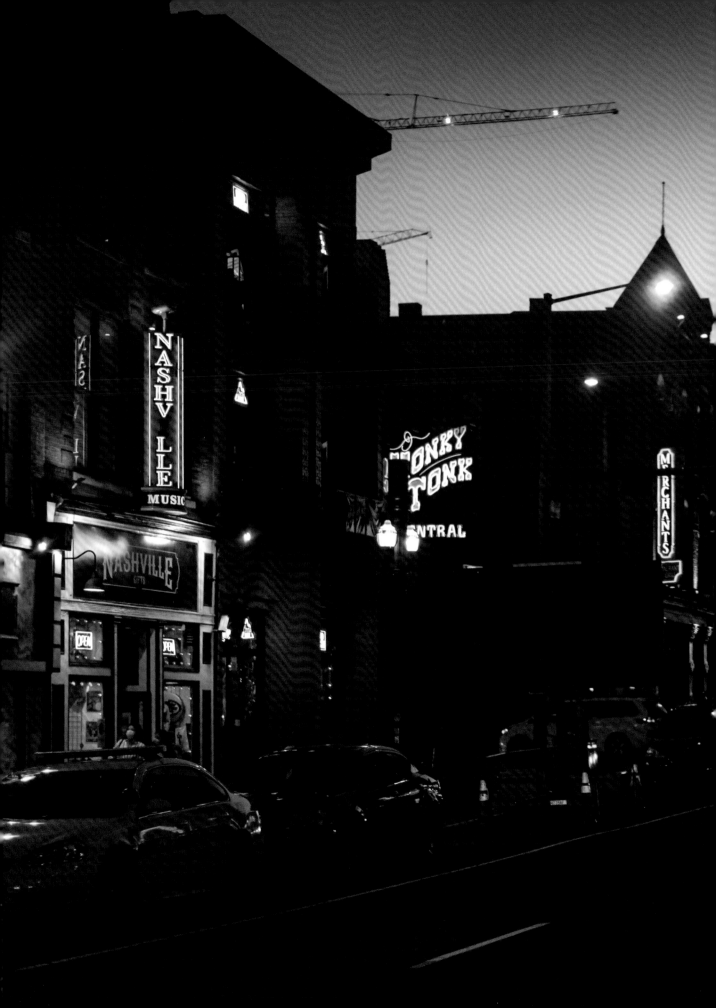

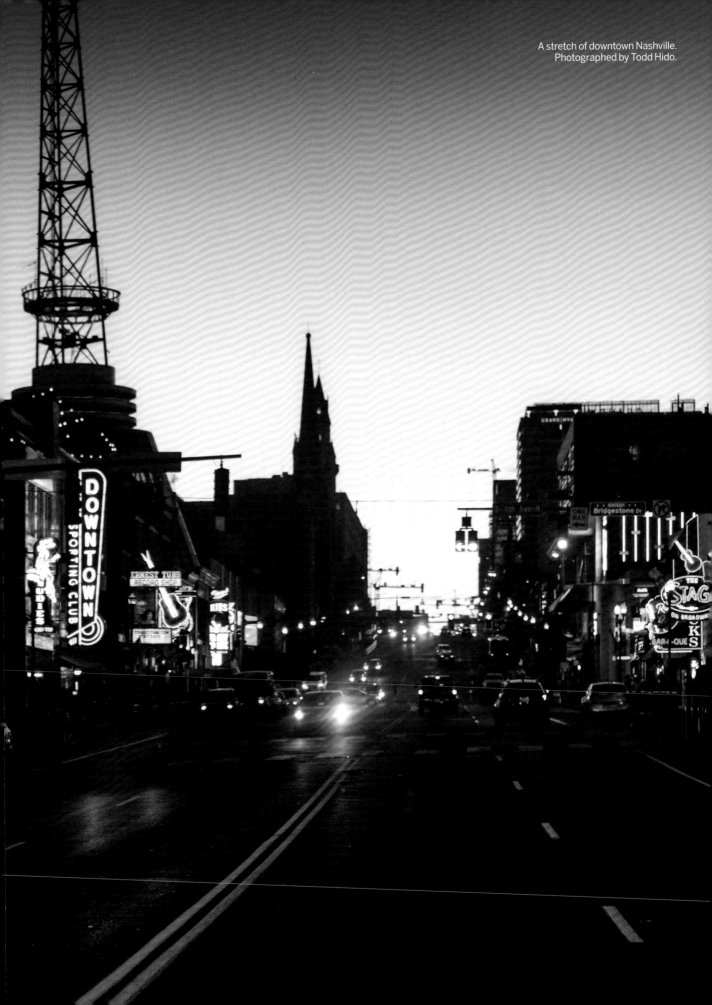

A stretch of downtown Nashville.
Photographed by Todd Hido.

ABLE, NASHVILLE, TENNESSEE

Many brands tout their sustainability credits, but Able—known for its classic leather bags, animal-print shoes, and dainty jewelry—did something almost unheard of when it published the lowest wages of the workers in its supply chain in 2018. "We shared all our results before we had everyone at a living wage, because we value honesty over perfection," says Jen Milam, Able's director of merchandising. It's something that likely couldn't be done without a strong sense of both community responsibility and community support—both of which Able is surrounded by. "There's a shared sense of mindfulness amongst Nashville designers," says fashion director Jordan Soderholm. The area's country flair has also permeated its designs, but Able accessories are defined foremost by their durability. After all, what's more ethical than wearing something year after year?

ABOVE, FROM LEFT: Able's design director, Krista Alexander; Barrett Ward, the brand's founder and CEO; and Jordan Soderholm, the brand's fashion director. OPPOSITE: Sierra Smith, Able's apparel designer (CENTER) with Alexander. Photographed by Todd Hido.

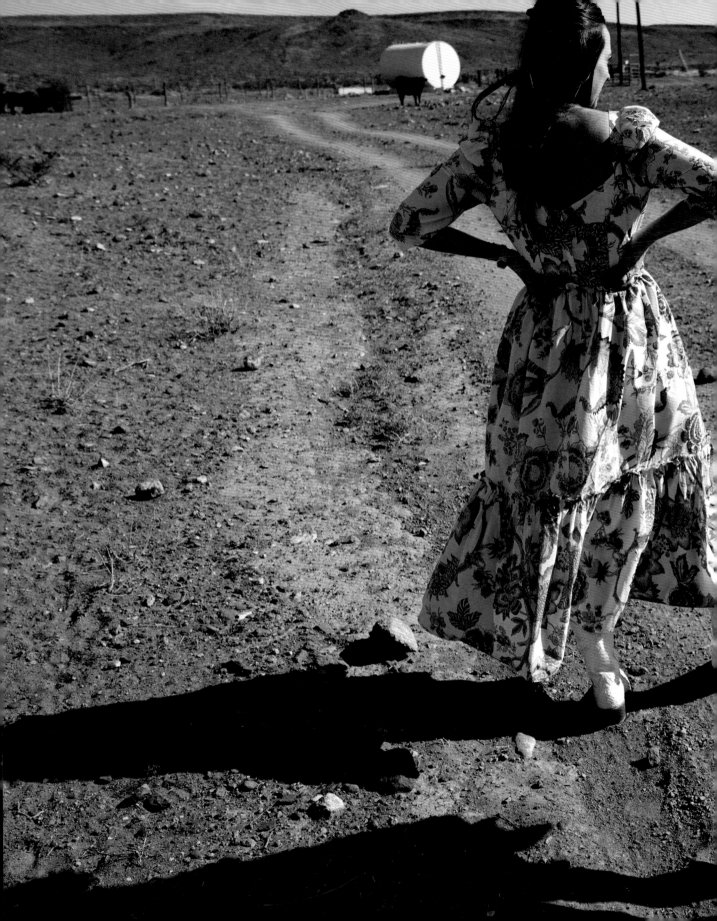

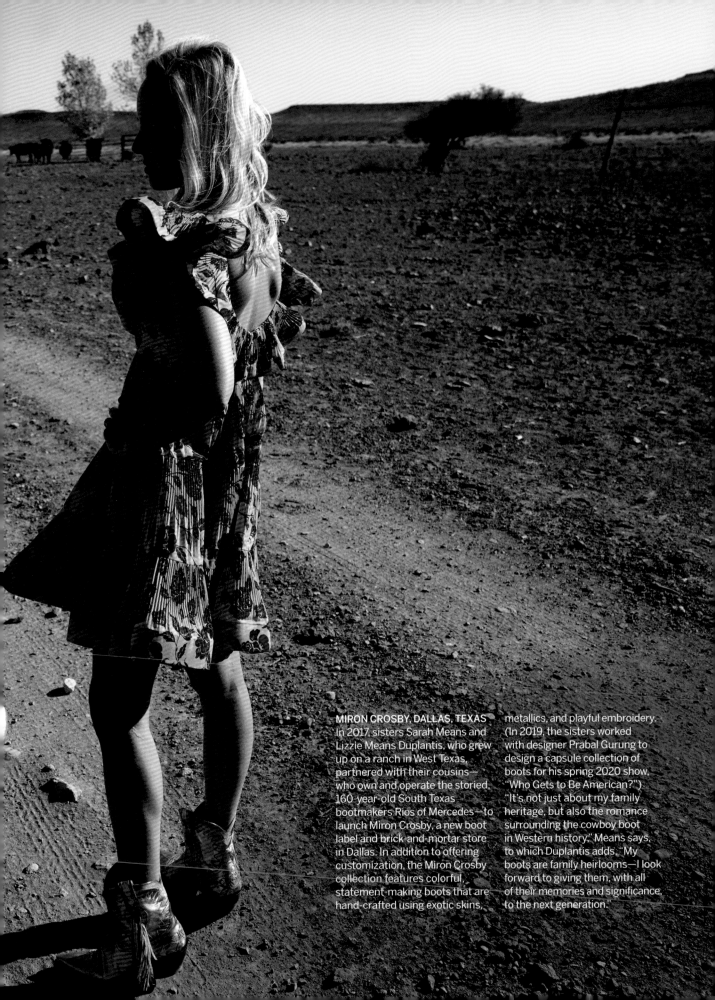

MIRON CROSBY, DALLAS, TEXAS
In 2017, sisters Sarah Means and Lizzie Means Duplantis, who grew up on a ranch in West Texas, partnered with their cousins—who own and operate the storied, 160-year-old South Texas bootmakers Rios of Mercedes—to launch Miron Crosby, a new boot label and brick-and-mortar store in Dallas. In addition to offering customization, the Miron Crosby collection features colorful, statement-making boots that are hand-crafted using exotic skins, metallics, and playful embroidery. (In 2019, the sisters worked with designer Prabal Gurung to design a capsule collection of boots for his spring 2020 show, "Who Gets to Be American?") "It's not just about my family heritage, but also the romance surrounding the cowboy boot in Western history," Means says, to which Duplantis adds, "My boots are family heirlooms—I look forward to giving them, with all of their memories and significance, to the next generation."

ABOVE: A mood board in Alchemist's workspace. OPPOSITE: Model Jonathan Prieto, in looks from the brand. Photographed by Richard Bencosme.

ALCHEMIST, MIAMI, FLORIDA

"Once upon a time, Miami's fashion codes were more club culture and a lazy, beach-life energy—but these days there is a richer cultural element and a strong art community, which fosters its own unique space and style." So says Alchemist founder Roma Cohen, who first introduced the city to Rick Owens and Chrome Hearts when he opened his store in 2007. Since then, Cohen has launched his own collection of graphic and fashion-forward pieces that bring a street aesthetic to the beachy town. "Especially during 2020, it was so important to reconnect with our local community, where there is endless inspiration all around," he says. His local approach seems to be working: Citizens of the world like Young Thug, Swae Lee, and Colombian singer J Balvin have all become customers.

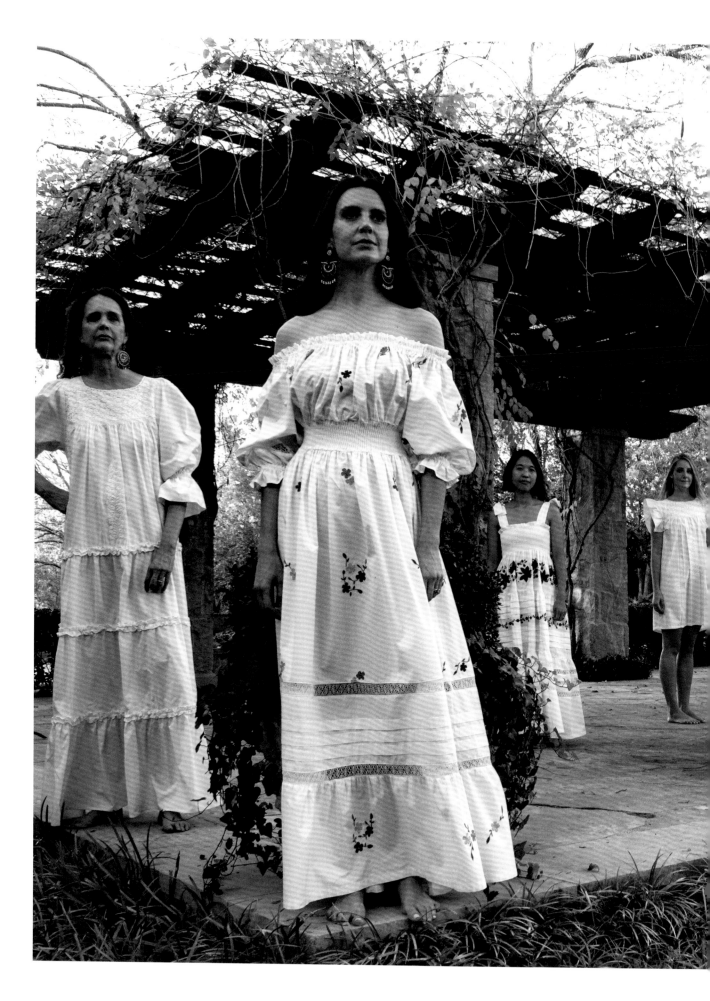

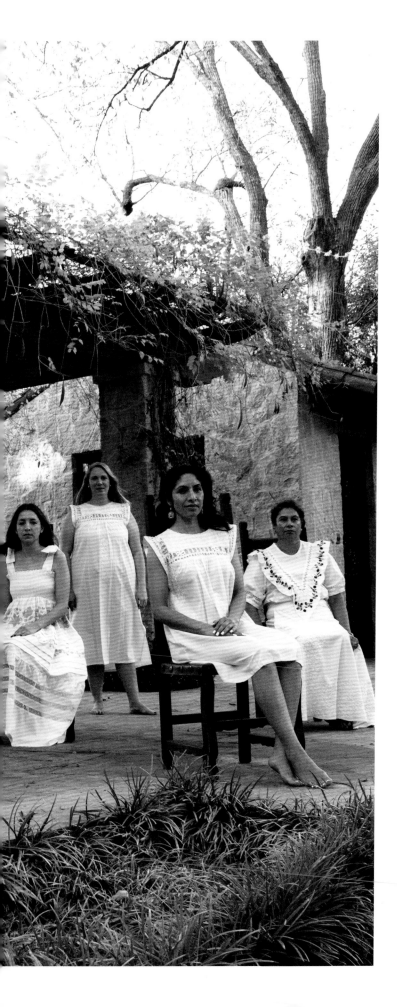

MI GOLONDRINA, DALLAS, TEXAS

The American melting pot is evident within the walls of Mi Golondrina, Cristina Lynch's showroom dedicated to Mexican handicraft. Inspired by her mother's upbringing in Torreón and the beauty of the clothing and art she experienced as a child, Lynch wanted to share those traditions with the world. In 2013, at the start of her journey, Lynch was advised to stay local. With its massive population and Southwestern aesthetic (the influence of Mexican design is omnipresent here), Texas was an ideal starting point. "What's neat is that each city—Dallas, Fort Worth, Amarillo, Houston—has its personality, and there's so much growth opportunity," says Lynch. "People support small businesses here, and they want you to succeed."

Still, Lynch felt that the richly detailed dresses and skirts she commissioned from artisans could appeal outside the Lone Star State. After all, what's familiar in one region registers as revolutionary in another. "This is wildly new to some customers," she says. "They're excited to see such intricate embroidery." Thanks to the internet—and high-profile admirers like Mindy Kaling—Lynch's wares have gone global, a fact she finds heartening. "It's so freeing and beautiful that fashion is now coming from different places across the country," she says. "It helps us understand our nation better, and I love that."

FROM FAR LEFT: Designer Cristina Lynch's mother, Cristina Barboglio Lynch; Cristina Lynch; and members of Lynch's team at Mi Golondrina: Anne Hong Gottschall, Devon Sadosky, Deanna Harney, Emily Reaves, Rebeca Esquivel, and Ma. de los Angeles Colmenero. Photographed by Colby Deal.

Mi Golondrina's Cristina Lynch.
Photographed by Colby Deal.

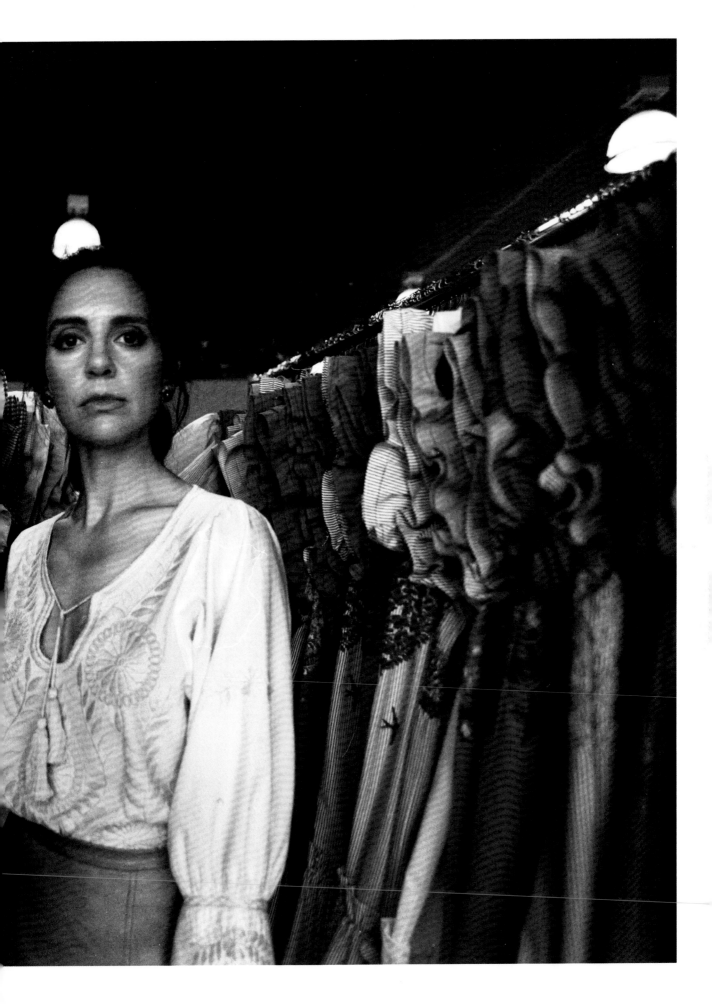

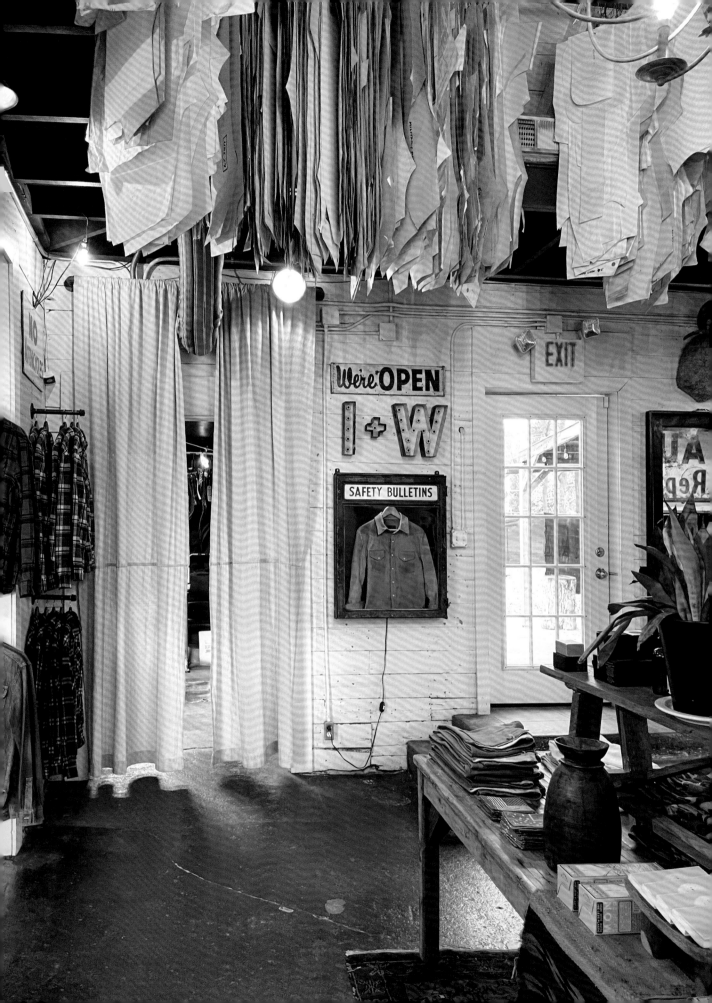

IMOGENE + WILLIE, NASHVILLE, TENNESSEE
In 2009, Carrie and Matt Eddmenson were patterning, cutting, and sewing jeans by hand in a converted Nashville gas station, selling them to customers on the spot—they even slept in the attic upstairs. Today, Imogene + Willie is a global brand. "None of this would have been possible in a larger city," Carrie says. "Nashville is the foundation of our story." The Eddmensons prioritize local production—including a denim-sourcing partnership with Vidalia Mills in Louisiana and a domestic sock collaboration with Little River Sock Mill in Alabama—and collaborate with other Nashville artists. "There is absolutely nothing better than knowing the people that make our clothes," Matt says.

ABOVE: A still life from the Eddmensons' studio. OPPOSITE: Inside Imogene + Willie's flagship store. Photographed by Todd Hido.

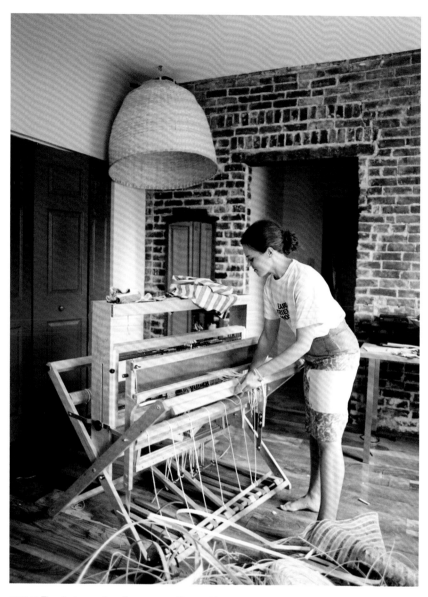

ABOVE: The designer at work. OPPOSITE: Dressed in a woven hat and skirt of her own design. Photographed by Luke Hans.

EMILY RIDINGS, LEXINGTON, KENTUCKY
Life, liberty, and the pursuit of happiness are the trifold tenets of the American ethos, and Emily Ridings—a Pratt graduate who has chosen her hometown of Lexington, Kentucky, as her base—is determined to exercise each of those rights through fashion. "One of my main goals is to enjoy my work," says the designer. "There's less financial pressure here, and less creative pressure to be new—relieving that pressure tends to invite the most joy. Surprisingly, joy has also been the best catalyst for success—not the other way around." Best known for weaving basketry into fashion, Ridings works with repurposed materials and traditional craft techniques, many of which have rural origins and narratives. Of turning away from New York City, the designer says she's "navigating what the alternative looks like," and reports that "so far, it's slower, just as messy—and much more hopeful."

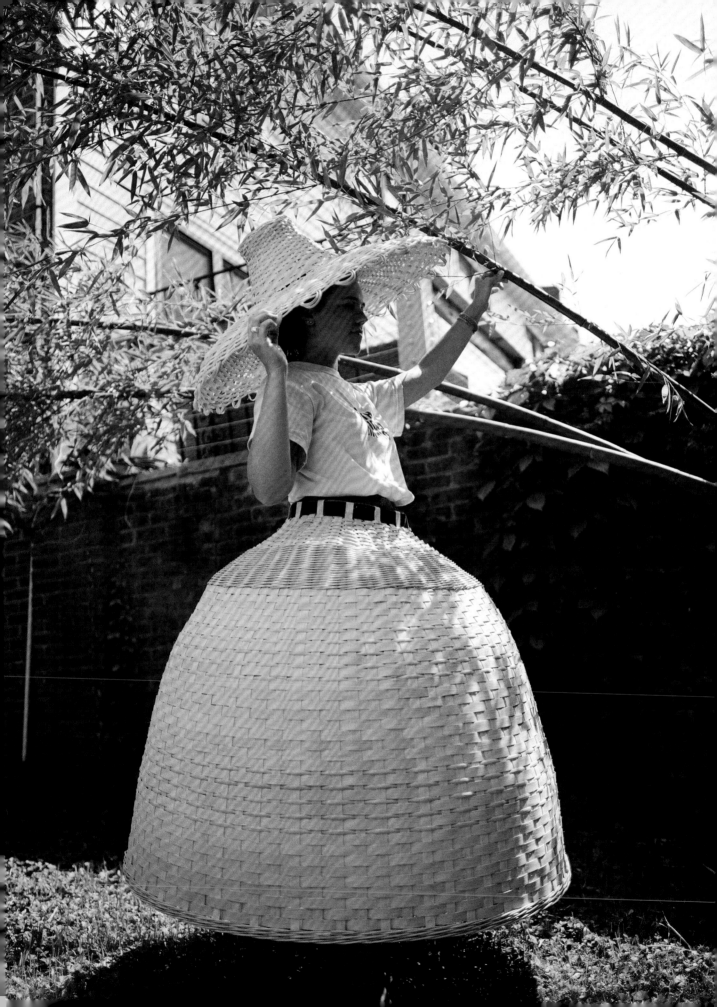

THE WEST

FASHION HAS LONG mythologized the American West, forging certain staples—gauzy dresses, cowboy boots—from its history and lore. Today, however, a growing number of designers are reworking those old codes and points of reference, finding inspiration in sources as wonderfully varied as Montana and New Mexico's Indigenous cultures, Hollywood, Las Vegas, and the surf in Southern California. If they have anything in common, it's a shared spirit of freedom and adventure, one articulated by The Elder Statesman's Greg Chait. "We are about being free-spirited—that's what we have in Los Angeles," he says. "Fashion isn't L.A.'s first language, but creativity is."

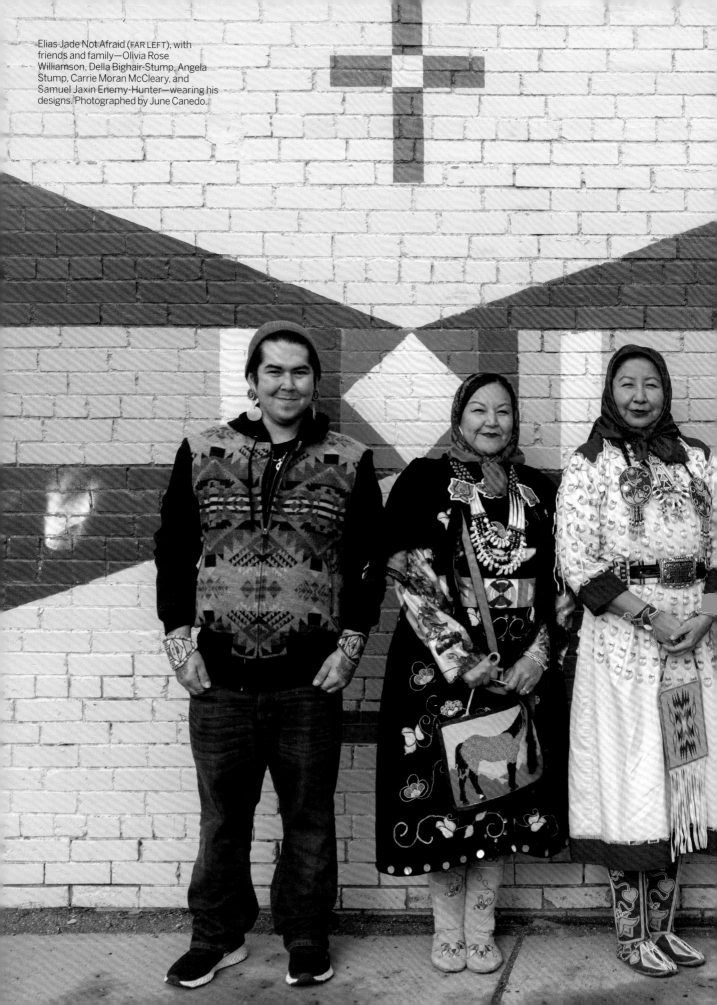

Elias Jade Not Afraid (FAR LEFT), with friends and family—Olivia Rose Williamson, Della Bighair-Stump, Angela Stump, Carrie Moran McCleary, and Samuel Jaxin Enemy-Hunter—wearing his designs. Photographed by June Canedo.

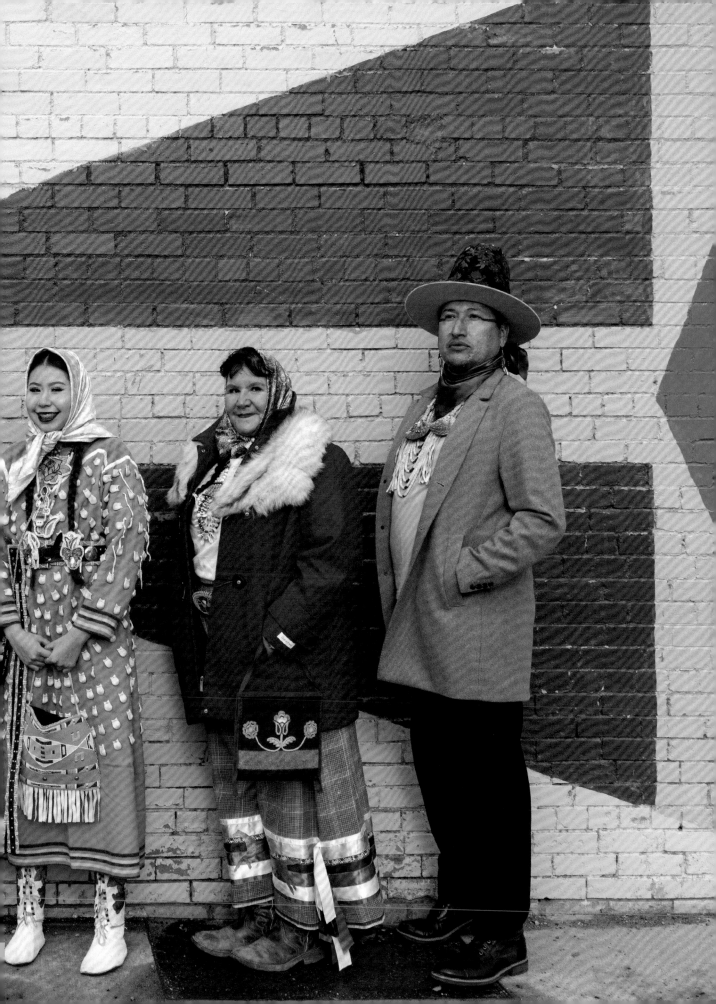

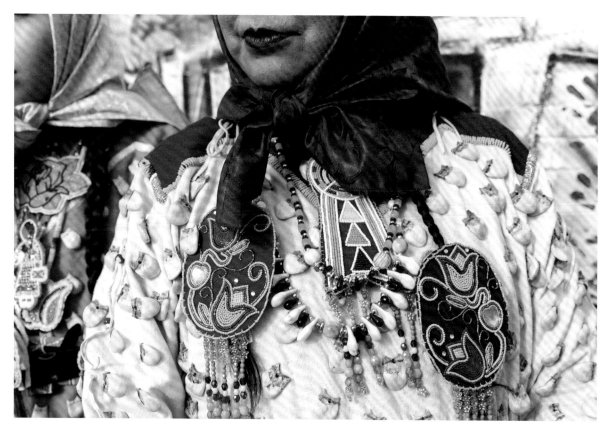

ABOVE: A pair of necklaces assembled from Venetian trade beads, elk ivory, pink conch shells, and vintage brass beads. OPPOSITE: The local site where Yellow Leggings, a forebear of the Apsáalooke people, had one of his fabled visions. Photographed by June Canedo.

ELIAS JADE NOT AFRAID, LODGE GRASS, MONTANA

Elias Jade Not Afraid, an Apsáalooke beadwork artist, learned his craft while being raised on Montana's Crow Indian reservation. "I grew up in my great-grandmother's house, and I was always bored," he says. "She had her beading equipment in cedar chests, so I would get a needle and thread and try to replicate what she did. Beading was my escape." Eventually he began combining edgier finishings, such as skulls or spikes, with traditional floral motifs. "We grew up in the country, so it was either stay inside or go outside; I always chose outside." Today, his work—like his tribe's—traces back to the land. "You can learn a lot about Crow beadwork," he says, "by just looking at the plants around here."

Model Aneita Moore (OPPOSITE) and a Libertine designer Helena Grierson (ABOVE) in Libertine. Photographed by Johnson Hartig.

LIBERTINE, LOS ANGELES, CALIFORNIA

"Wherever a creative person is, they will be creative," says Johnson Hartig of Los Angeles–based Libertine, the quirky-clever label that plays with all sorts of vintage tropes—and then embellishes them like crazy, with a Hollywood-like sprinkling of nostalgic stardust to reinvent the past for the present. "I studied art," he says by way of explanation. "I love decorating surfaces." While Hartig is L.A.-born and bred, he has also been an inveterate traveler. "My inspiration comes from India and the Far East, Hindi and Ottoman cultures—I'd take two or three major trips a year to replenish my well," he says. If COVID put a halt to that, "It's been nice to have more time to garden."

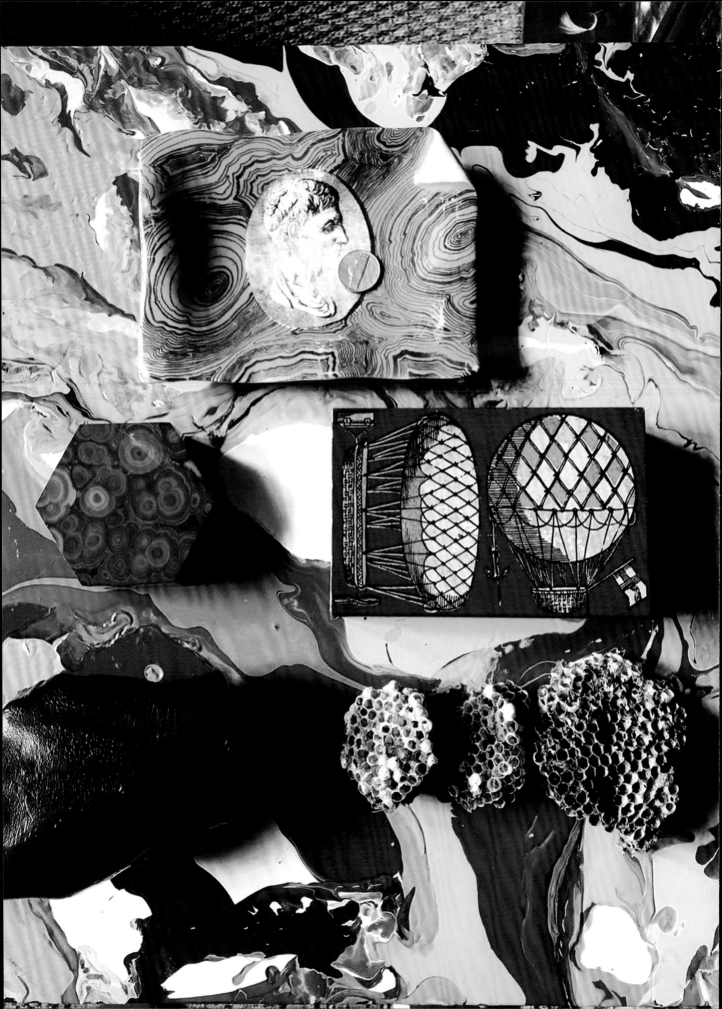

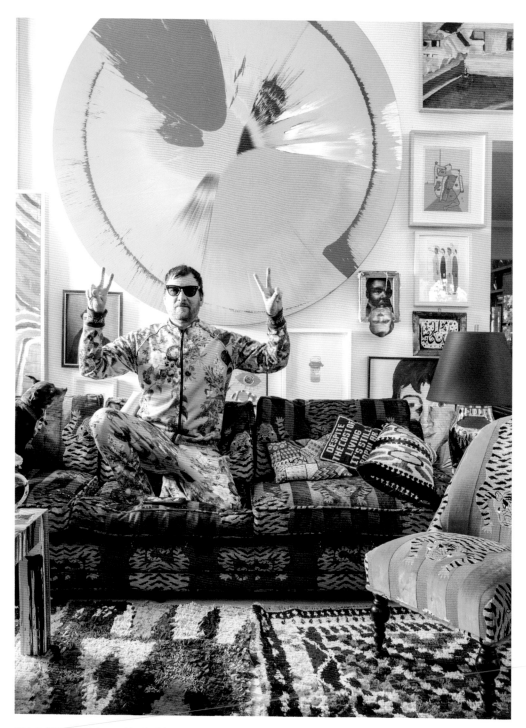

ABOVE: Designer Johnson Hartig. Photographed by Paul Costello. OPPOSITE: A vintage Fornasetti ashtray, a match safe, wasp nests, and other objects on a table hand-marbelized by Hartig. Photographed by Johnson Hartig.

RODARTE, LOS ANGELES, CALIFORNIA

Kate and Laura Mulleavy have always had a deep connection to their home state of California, drawing on its natural beauty for inspiration since the inception of their Rodarte label in 2005. Resisting the siren call of the New York fashion scene, the sisters built a community of like-minded collaborators in Los Angeles, including their longtime stylist Shirley Kurata and the photographer and director Autumn de Wilde. "Sometimes when you push all of fashion onto one platform, it ends up destroying uniqueness," says Kate. Adds Laura, "It's only when you open up that landscape that independent voices can come to the fore—and that's what makes this moment so exciting. This new generation is taking us to places we didn't know we could go."

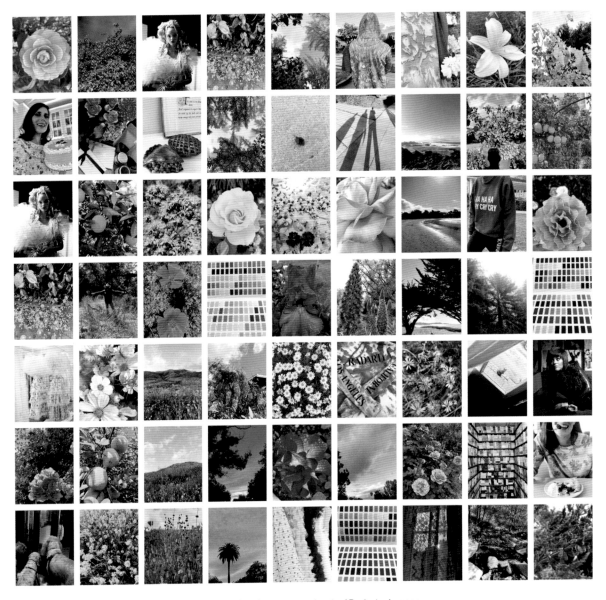

ABOVE: Impressions from the Mulleavy sisters' life and work. OPPOSITE: A pair of Rodarte dresses. Photographed by Kate and Laura Mulleavy.

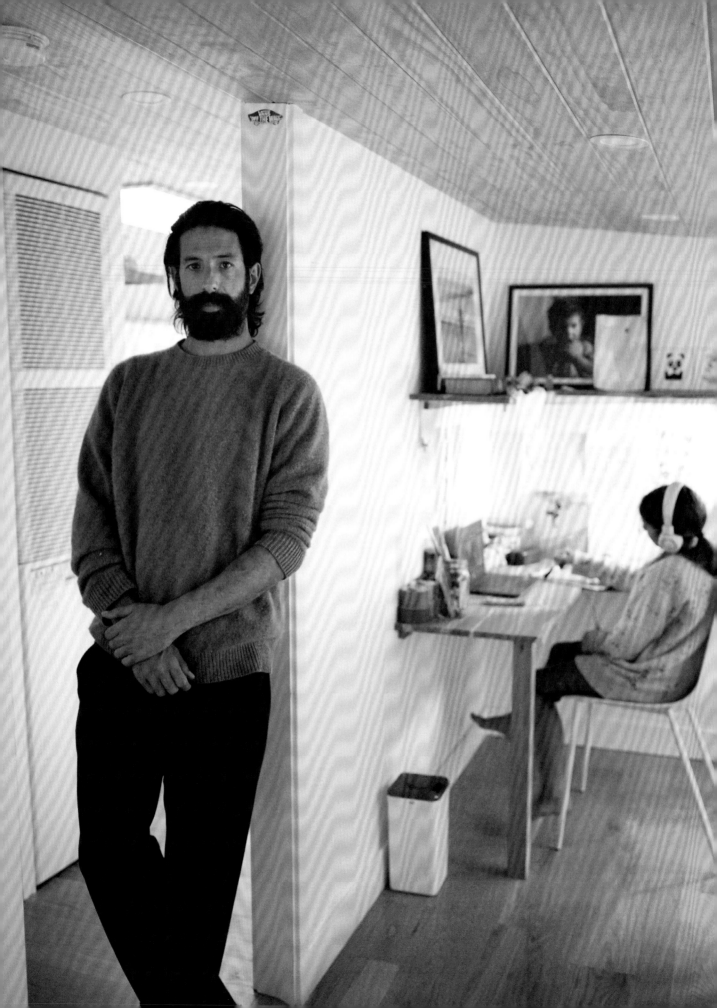

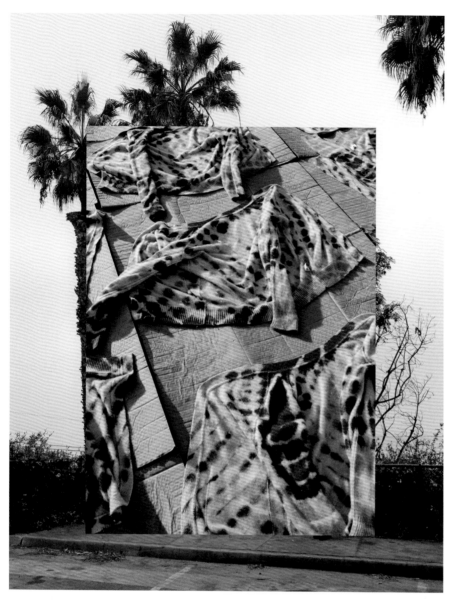

ABOVE: An artful arrangement of knits by The Elder Statesman. OPPOSITE: Designer Greg Chait at home with his daughter, Dorothy Sue. Photographed by Liam MacRae.

THE ELDER STATESMAN, LOS ANGELES, CALIFORNIA

"We are about being free-spirited—that's what we have in Los Angeles," says Greg Chait, founder of The Elder Statesman. "Fashion isn't L.A.'s first language, but creativity is." Chait's knitwear label (the 2012 CFDA/*Vogue* Fashion Fund winner) offers boho/luxe cashmere in a groovy earthy-goes-cosmic color palette. Many of the pieces are created by his team of knitters working both at the label's downtown Los Angeles studio and from their homes, artisans Chait considers the label's lifeblood. "You have to lean into craft that's exceptional," he says.

ABOVE: Colorful creations from The Elder Statesman. OPPOSITE: Chait, in his Los Angeles studio. Photographed by Liam MacRae.

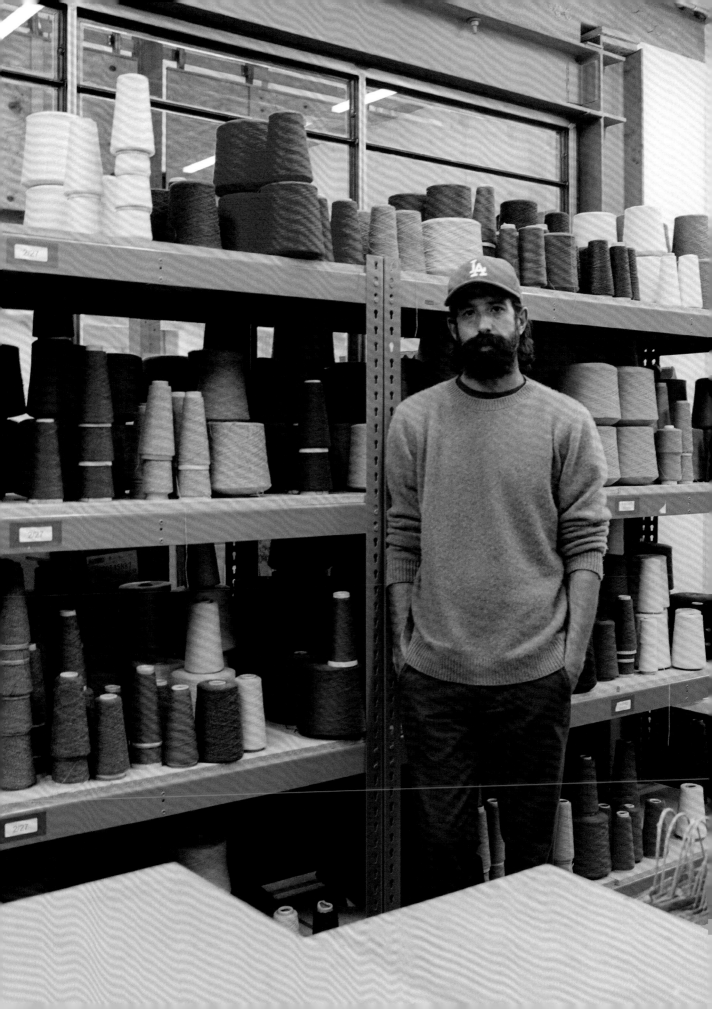

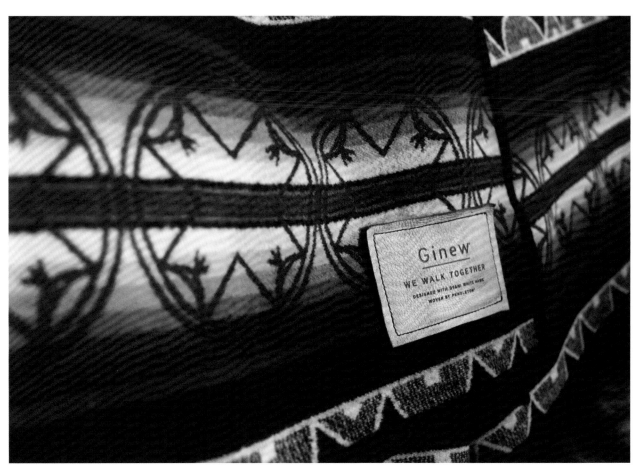

Ginew's Pendleton wool blankets, featuring a crest that references both the Ojibwe and Oneida tribes.

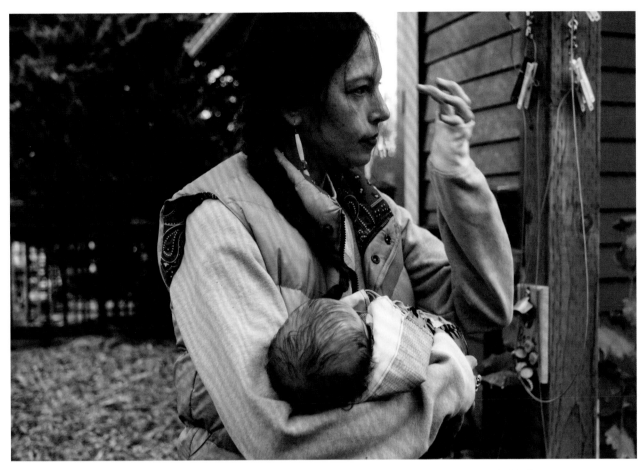

Designer Amanda Bruegl with Honuhōkūlaniokauna'oa Ninham Brodt, her daughter with Erik Brodt. Photographed by Kari Rowe.

GINEW, PORTLAND, OREGON

Ginew, an Indigenous denim line, is the passion project of Erik Brodt (Ojibwe) and Amanda Bruegl (Oneida and Stockbridge-Munsee). By day, Bruegl is a gynecologic oncologist and Brodt a family physician, but in 2011 they launched Ginew with the intent of giving denim a Native American twist. "Indians make the best cowboys," says Brodt. "We embody a huge portion of denim history, and it's almost like we've been erased from it." The couple both grew up in northern Wisconsin, but moved to Portland in 2015 for work. Living there has continued to influence their designs. "You have easy access to places that are truly isolated," says Brodt. "You definitely feel like you're part of the earth. The very first time you walk out onto the beach at the Pacific Ocean, there's this overwhelming sense of how small you are. A lot of the denim we do, to me, looks like Lake Superior, too; it has really deep, eerie, cloud-colored blues at certain times."

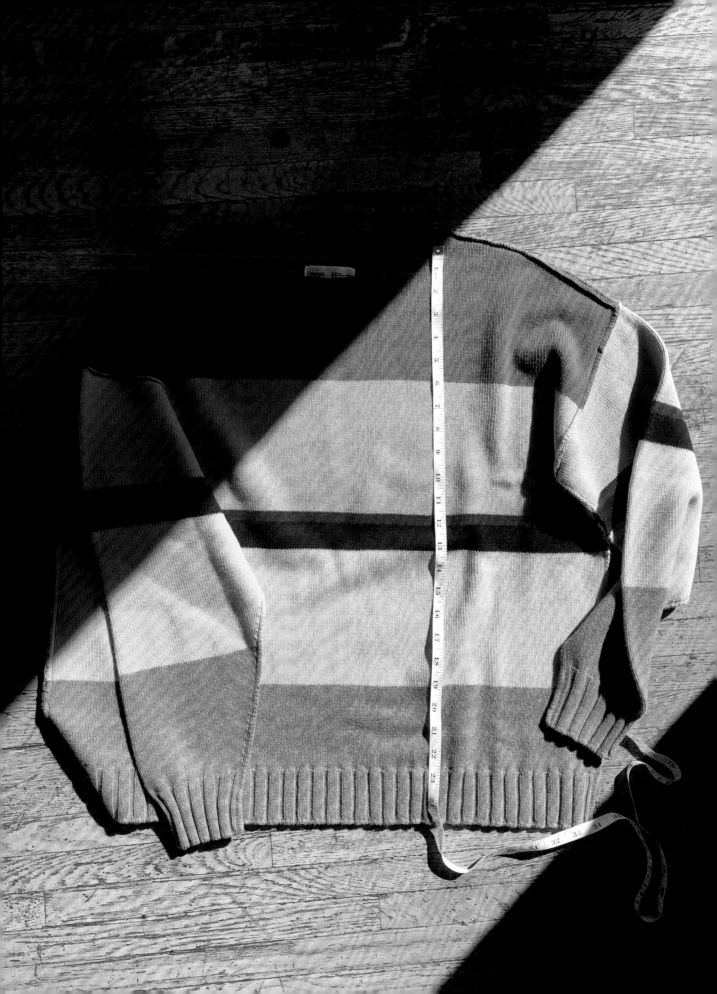

ENTIREWORLD, LOS ANGELES, CALIFORNIA

Scott Sternberg built both his brands—the late, lamented Band of Outsiders and the pandemic-proof basics label Entireworld—in Los Angeles. But where Band was East Coast prepster and played by the New York Fashion Week rules, Entireworld's matching sweatsuits and direct-to-consumer sales model are pure California. "You go to dinner here, and there are drawstrings involved," Sternberg says, laughing. "There's a shift of values going on: Where we put our money, the role that brands play in our lives, the importance of buying less but buying better." Staying focused has been the name of his game: He's going deep on sweats and launching what he calls a "low-impact legging" that's more natural-feeling than true exercise gear. "We don't need to keep adding more and more stuff," he says. "I'm more clear about what doesn't belong."

ABOVE: A drying rack in the music room of designer Scott Sternberg's Los Angeles home. OPPOSITE: A sweater from Entireworld. Photographed by Scott Sternberg.

BACK BEAT CO., LOS ANGELES, CALIFORNIA
Isadora Alvarez, the Filipino-born founder of Back Beat Co., established in 2016, calls her pieces "Cali-inspired, low-impact clothing." Indeed, the fabrics making up the label's surf-and-skate-inspired separates—waffle-knit joggers, cropped puffer jackets, perfect hoodies—are all either recycled or made from sustainably harvested crops, with other thoughtful initiatives still in the offing. "We're working on a program where we can take back old clothing we've sold and create new yarns out of it," Alvarez says. (Systems for repairing and upcycling are also on her list.) As long as Back Beat produces new pieces, minimizing waste will be the top priority: "That's the dream," she says, "and the goal."

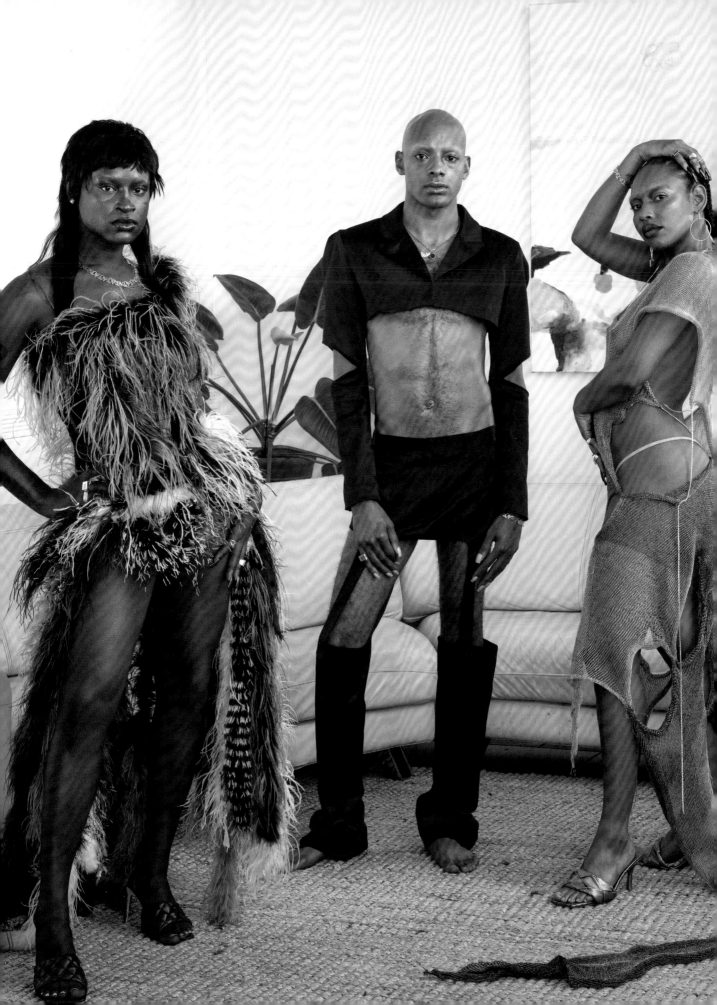

ABOVE: A sweater in the No Sesso studio. OPPOSITE, FROM LEFT: Pierre Davis, Arin Hayes, and Autumn Randolph.

NO SESSO, LOS ANGELES, CALIFORNIA

"No Sesso could exist anywhere in the world," says the brand's cofounder and head designer, Pierre Davis. And while its hand-embroidered and genderless pieces may have a universal appeal for their vibrant aesthetic, the brand—founded by Davis and Arin Hayes in 2015—is proudly operated out of Los Angeles. "We just have so many resources literally around us," Davis says. "Everyone is so open and interested in experimenting and evolving." When the COVID-19 virus put a hold on in-person events—"This time has really tested how you adapt to showing up for other people and yourself in a new way," co-designer Autumn Randolph says— the trio placed a focus on direct-to-consumer sales and connecting with their communities, virtually or otherwise. "Some things have changed, some have stayed the same, but the pandemic has made me cherish our collaborators even more," says Randolph.

An assemblage of Diarrablu
fabrics. Photographed by
Clifford Prince King.

DIARRABLU, SAN FRANCISCO, CALIFORNIA
Diarra Bousso grew up in Dakar, Senegal, where she produces her label Diarrablu, but spends most of her time in San Francisco, working as a mathematics educator. "Living and working in San Francisco is very inspiring," Bousso says. "I am constantly trying to find ways to humanely use technology in my work while still empowering our culture and our artisans." Every garment is made to order to avoid excess stock, and Bousso has drawn up her own algorithms to create designs virtually and crowdsource and produce only what's needed. Many of the artisans at Diarrablu are family members who have spent decades perfecting their crafts in leather, jewelry, ceramics, and more. "It's more than just a product," she says. "It's a whole story about who we are, and it's very powerful."

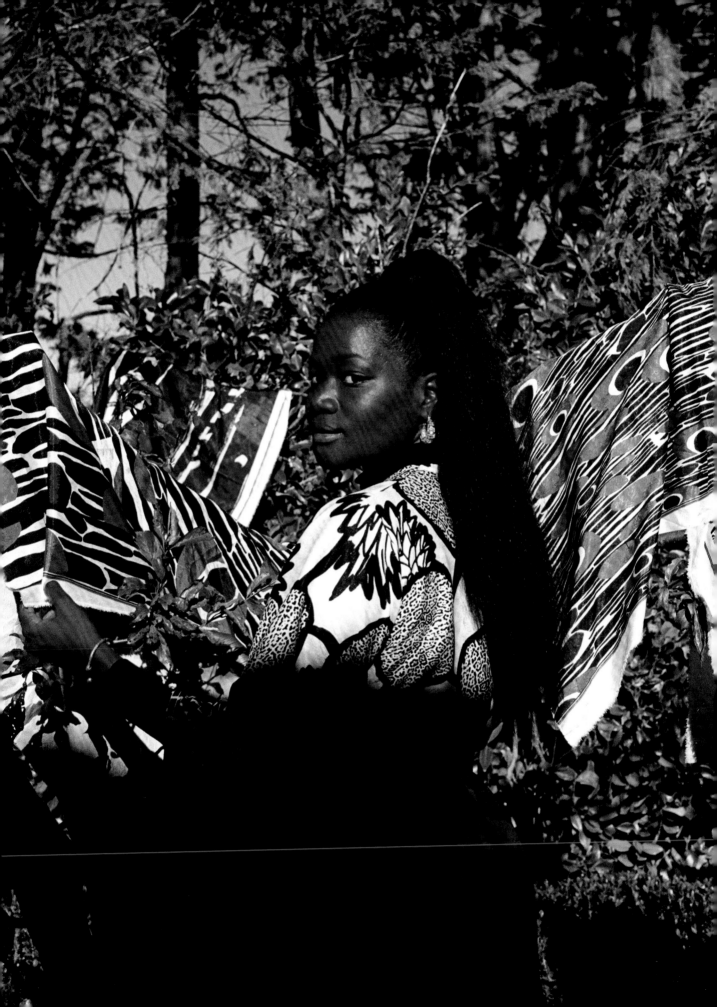

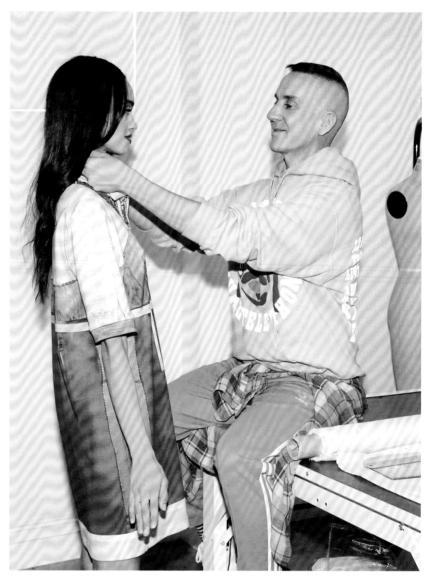

ABOVE AND OPPOSITE: The designer and model Ellen Rosa, dressed in Moschino Couture. Photographed by Marcus Mam.

JEREMY SCOTT, LOS ANGELES, CALIFORNIA

Is it any wonder that Jeremy Scott went Hollywood? The Kansas City, Missouri, native dazzled Paris in the late '90s—he was briefly taken under Karl Lagerfeld's wing, in fact—but his camp aesthetic and affinity for pop culture were always more American than French. In 2001, he moved where the celebrities are and soon started dressing everyone from Lady Gaga to Katy Perry. "I literally am from pioneer stock, and I just came out here to sift for gold," Scott says. "It was one of the most difficult decisions that I've ever made—and also the smartest." His spring 2021 Moschino presentation—a re-creation of a couture show made in collaboration with Jim Henson's Creature Shop (the maker of the Muppets) and starring a marionette version of Scott's fellow Angeleno Gigi Hadid—was so well received that he began working on another film for fall 2021, this time with real humans.

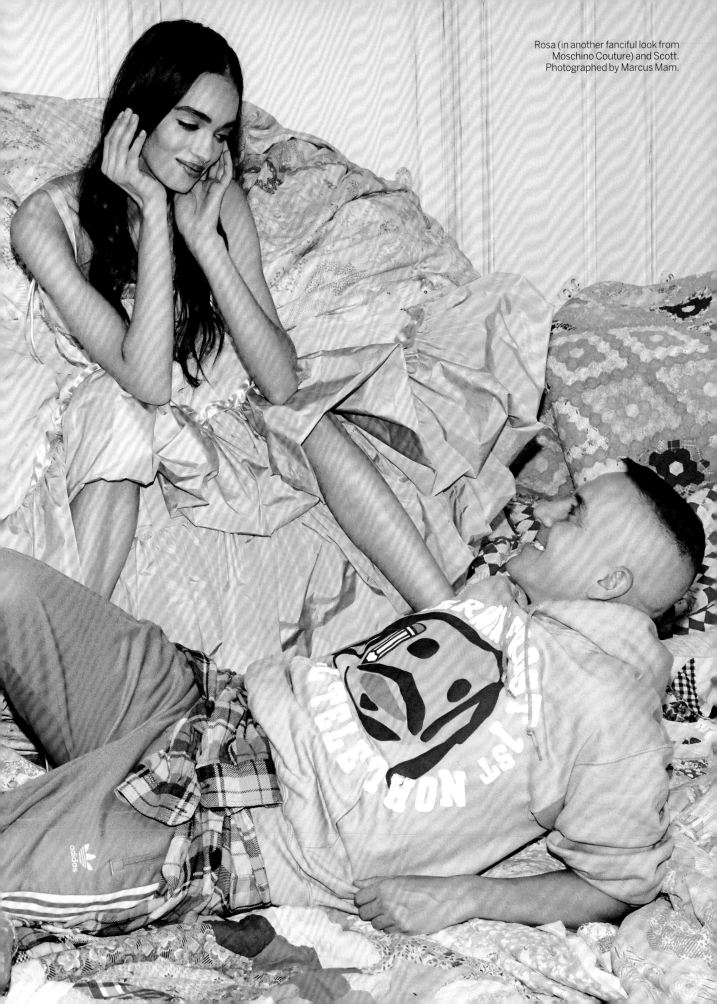

Rosa (in another fanciful look from Moschino Couture) and Scott. Photographed by Marcus Mam.

HARWELL GODFREY, SAN FRANCISCO, CALIFORNIA
After spending more than 15 years working as an art and creative director, Lauren Harwell Godfrey decided to follow her passion in 2013 by enrolling in the San Francisco Cooking School. She staged at the legendary Bar Tartine and Chez Panisse, and in the process learned to love working with her hands—and in short order, she took up jewelry-making, crafting special pieces for herself and her friends. In 2018, her self-titled label of fine jewelry was born. Still based in the Bay Area, Harwell Godfrey works with precious metals and gemstones like malachite, sapphire, and 18K yellow gold. "There's something intuitive about working with your hands," she says. "That's part of the attraction of both food and jewelry: A process with many components that results in something bigger than the sum of its parts has always appealed to me."

ABOVE: Lauren Harwell Godfrey samples the produce at a local farmer's market. OPPOSITE: The designer with her dog, Woody. Photographed by Clifford Prince King.

Designer Lauren Bucquet.

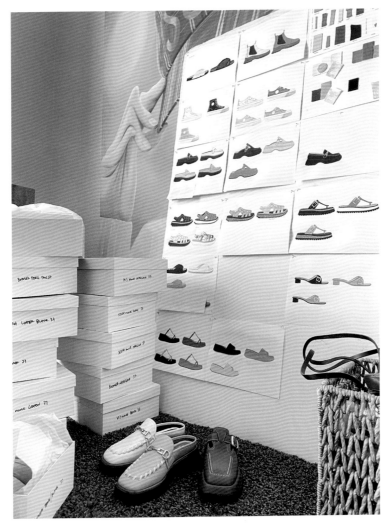

Labucq mock-ups and samples in Bucquet's home office.
Photographed by Adam Humphreys.

LABUCQ, LOS ANGELES, CALIFORNIA

When Lauren Bucquet decamped to Los Angeles with her husband, Adam, and their new baby, Norman, in 2017, after a decade in New York designing footwear and accessories for Rag & Bone, she found that distance from American fashion's epicenter helped clarify what a label of her own could look like. "I'd always wanted to start a brand," she says, "but I wanted to do it on my own terms." In 2018 she launched Labucq, creating what she hadn't yet seen in the direct-to-consumer marketplace: accessibly priced shoes that were, yes, made in Italy, but had

a distinct design sensibility, too. "It's fashion and it's contemporary and trend-driven, but it's also something that you want to put on every day," Bucquet says. Made up of just four employees (including Bucquet and her husband), Labucq has been a decidedly DIY operation, made only scrappier by world events: In March of 2020, Bucquet and her family decamped to Las Vegas, where her parents had a house on the market. For the moment, however, she wouldn't have things any other way. "I'm very, very remote," she says. "But we're managing just fine."

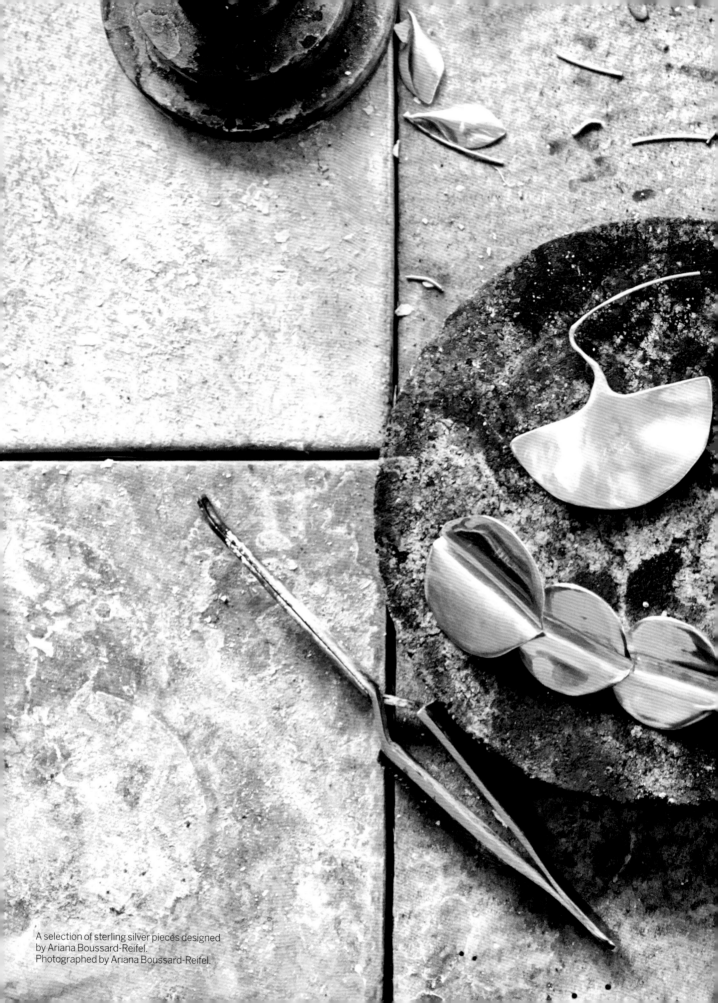

A selection of sterling silver pieces designed
by Ariana Boussard-Reifel.
Photographed by Ariana Boussard-Reifel.

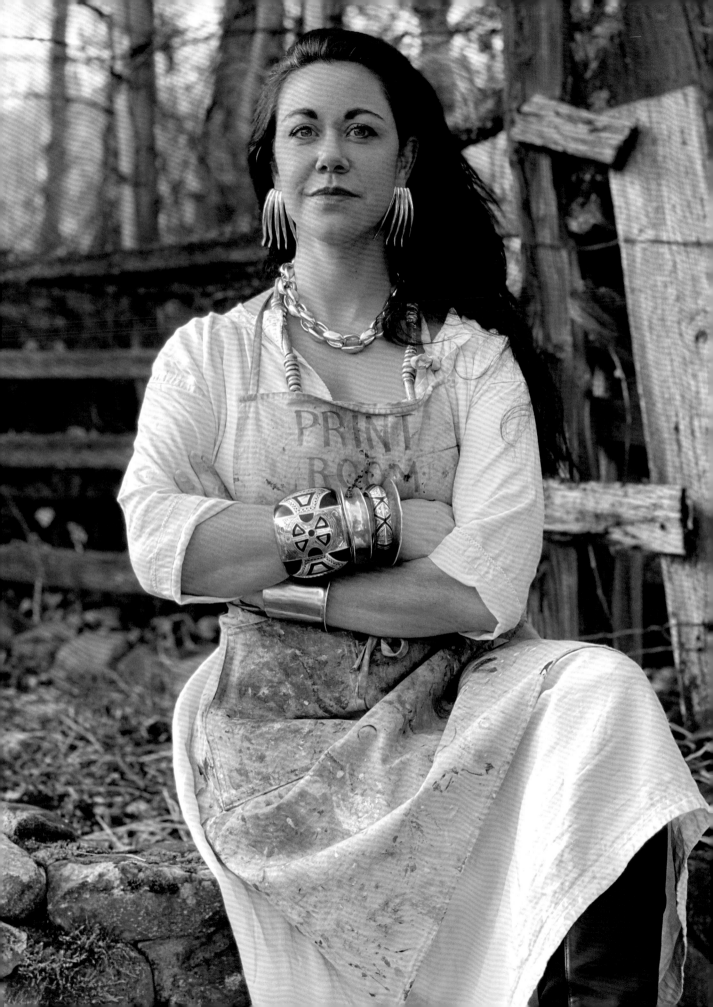

The designer. Photographed by
Yasser Ansari.

ARIANA BOUSSARD-REIFEL, WESTERN MONTANA
Ariana Boussard-Reifel, a sculptor turned jewelry
designer, grew up on a Salish and Kootenai
reservation in western Montana (though her family
is Lebanese and German), and has always been
inspired by ethnographic jewelry and fashion.
This inspiration originally gave life to Marteau—a
collection of vintage and antique jewelry that evokes
tribal and Indigenous cultures—and then turned
into her self-titled jewelry line of "small, wearable
sculptures" in 2016. Boussard-Reifel, who splits her
time between New York City and her family ranch
near Missoula, believes that not only should
her jewelry make one feel "like a goddess," but it also
owes a debt to Indigenous fashion—something
reflected in her designs, which range from bold brass
cuffs worthy of Wonder Woman to a breastplate
necklace inspired by tribal Chinese designs. And
while it certainly helps when people like Beyoncé
wear her pieces, "the biggest validation,"
Boussard-Reifel says, "is when my customers say,
'When I wear this, I feel like my best self.' "

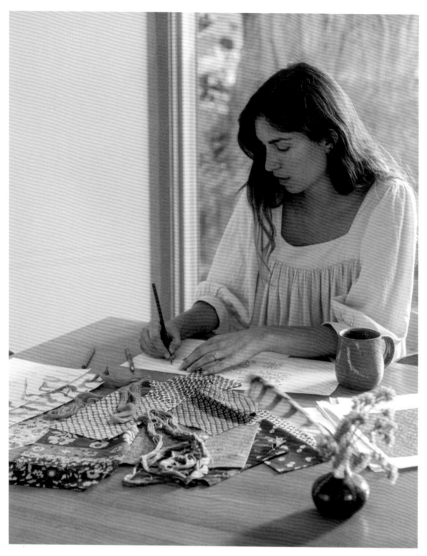

ABOVE: Designer Christy Dawn Baskauskas. OPPOSITE: A suite of Christy Dawn dresses at the Baskauskases' home in Rustic Canyon. Photographed by James Branaman.

CHRISTY DAWN, LOS ANGELES, CALIFORNIA
Christy Dawn Baskauskas and her husband, Aras Baskauskas, first turned to deadstock fabrics for their label, Christy Dawn, out of thrift: "The most cost-effective way was to start small and create limited pieces for our community and my friends," Christy explains. Yet as they learned just how toxic traditional production methods could be, the pair resolved to lean fully green. Today, they've engaged farmers and artisans in southern India to grow, gin, weave, dye, and print regenerative long-staple cotton. Their prairie-style dresses, though, evoke vistas much closer to home: Christy was raised in pastoral Northern California, and it cast its spell. "Mother Nature is a huge influence," she says.

A Chloe Gosselin velvet mule.

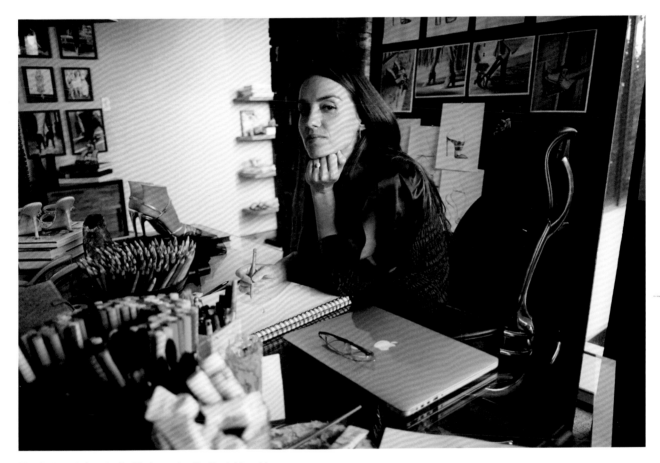

The designer in her studio. Photographed by Daniel Arnold.

CHLOE GOSSELIN, LAS VEGAS, NEVADA

Growing up just outside Paris, shoe designer and former model Chloe Gosselin used drawing as her main form of self-expression. She soon discovered fashion and fell head over heels, sketching figures and garments and obsessing over runway collections from John Galliano and Jean Paul Gaultier. She eventually made her way to a fine arts–and–painting school in Belgium and, later, to FIT in New York, where she studied shoemaking. Today, Gosselin's namesake label has become well known for its timeless, vintage-inspired designs. In March 2020, she began working exclusively in Las Vegas, where she lives with her husband, the magician David Copperfield, her daughter, and two stepchildren. Though her life has shifted and changed, her love of design, no matter where she's living, remains a constant. "Motherhood shaped my transition from modeling to designing," she says. "I wanted to make something for myself that would last—and I wanted to make my daughter proud."

BAR

PAID
100000

MAX BET 400

1¢

016204

INSERT BILL
RECEIVE TICKET

PLEASE KEEP 1 EMPTY
SLOT MACHINE BETWEEN YOU
& OTHERS NOT IN YOUR PARTY

PAYS

Quick Hit

400

200

120

A Chloe Gosselin sandal.
Photographed by Daniel Arnold.

Kenneth Nicholson (CENTER) with
his wife, Brooke Ochoa-Nicholson,
and their four young children.
Photographed by Paul Mpagi Sepuya.

KENNETH NICHOLSON, LOS ANGELES, CALIFORNIA
Los Angeles–based designer Kenneth Nicholson
launched his label in 2016, following his service in
the Navy. A true romantic who adores the process
of creating, Nicholson is influenced by his physical
location in an unexpected way. The pool-blue
pants and printed suits in his fall 2020 collection,
for instance, feel extraordinarily Californian, while
the corset-like top cut for a man belies Nicholson's
love for reworking fashion history. "When I spent
time in the Navy, and when I had time to create,
I found myself drawing from the inspiration of my
environment—thinking about the water, the ships,
the uniforms and the clean lines, the repetition,"
Nicholson says. "I don't know if it's California per se
[that I'm inspired by], as much as it is being an
artist in a particular environment and drawing on
the surroundings."

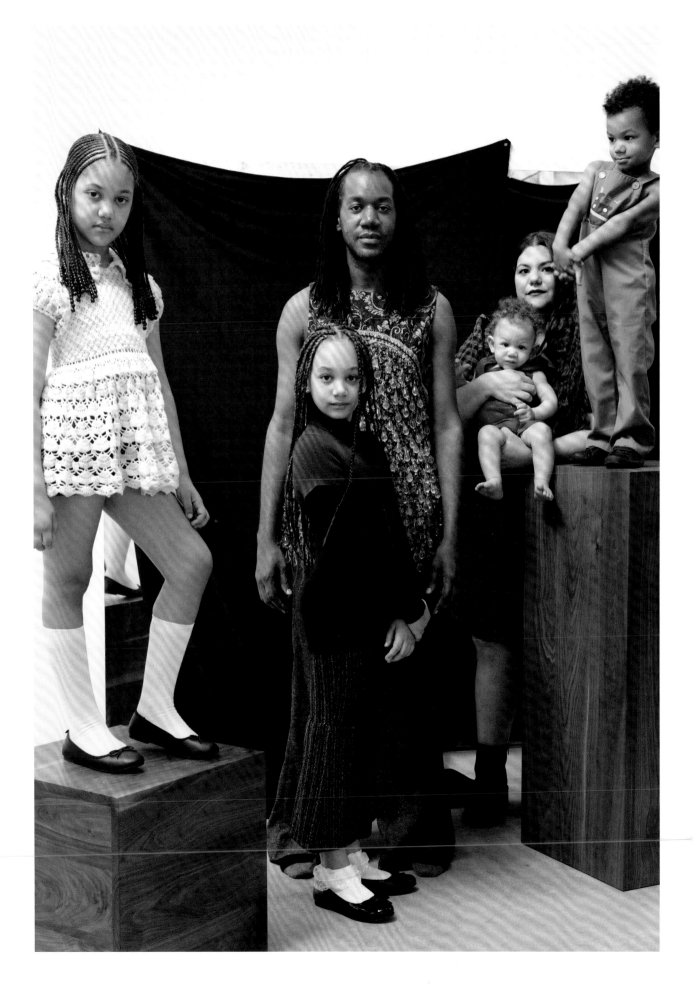

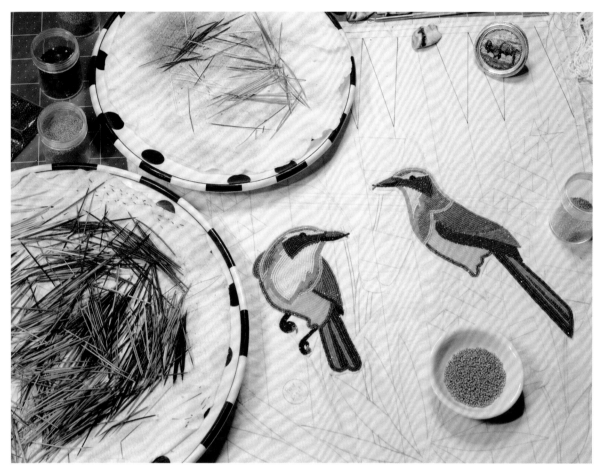

ABOVE: A work in progress. OPPOSITE: Sandra and Jamie Okuma, both wearing their own handiwork. Photographed by Sharon Lockhart.

JAMIE AND SANDRA OKUMA, PAUMA VALLEY, CALIFORNIA
Jamie Okuma may have followed in her mother Sandra's footsteps as an artist, but the Luiseño and Shoshone-Bannock duo create unique pieces that are completely different from each other's work. Sandra is a painter and beadwork artist; Jamie does beadwork, clothing, accessories, and even sculptures. "She has a different way of doing it than I do," says Jamie of their beadwork. "Generally, we both reference Plateau and Great Basin design, but she'll draw something out and really nail it down before she starts working it—I just can't do that!" Sometimes, however, they partner up on special pieces. "It's compatible when we do put it together," says Sandra. Jamie and Sandra are both based on the La Jolla Indian Reservation in Pauma Valley, California. "There's a deep history of our tribe and family here," Jamie says. Sandra has lived on the reservation almost her whole life, and she raised Jamie there, too. "When I was a kid, there was nothing here—we didn't even have a car," says Sandra. "But as a kid, it was heaven. There's a feeling of security here." Both artists draw from their reservation's community and picturesque setting for their art. "Being in nature is the foundation of my work," says Sandra. Jamie also finds pride in having never succumbed to the pressure to move to a bigger city. "I wouldn't want to raise my kids anywhere else."

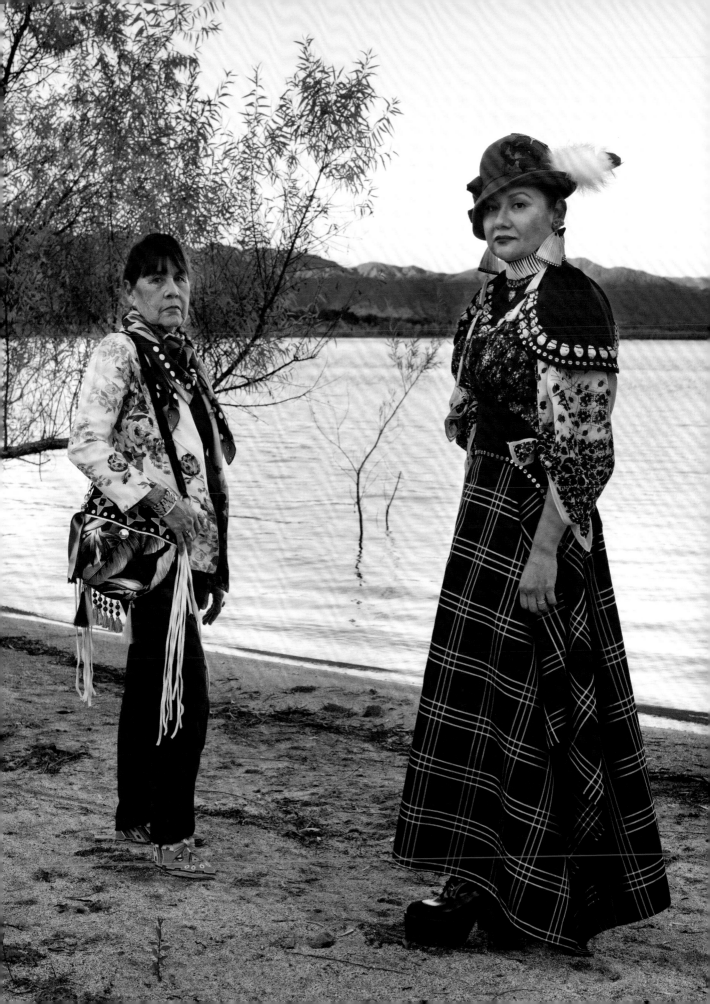

The designer, in earrings of her own design.
Photographed by Gillian Garcia.

SOPHIE BUHAI, LOS ANGELES, CALIFORNIA
"Beautiful and dark, elegant and tacky," is how Sophie Buhai, a fifth-generation local, describes the spirit of Los Angeles. It's the city's history—specifically in the early 20th century—that inspires her namesake jewelry brand, which is designed and produced in L.A. and name-checks famous Angelenos like Maya Deren, Rudolph Schindler, and Anaïs Nin. Buhai's greatest ambition is that her restrained, minimalist pieces will one day be as timeless and classic as the art made by those who inspired it. "The world doesn't need any more stuff, so if we're making something, let's make it last," she says, "with as little damage to the environment as possible."

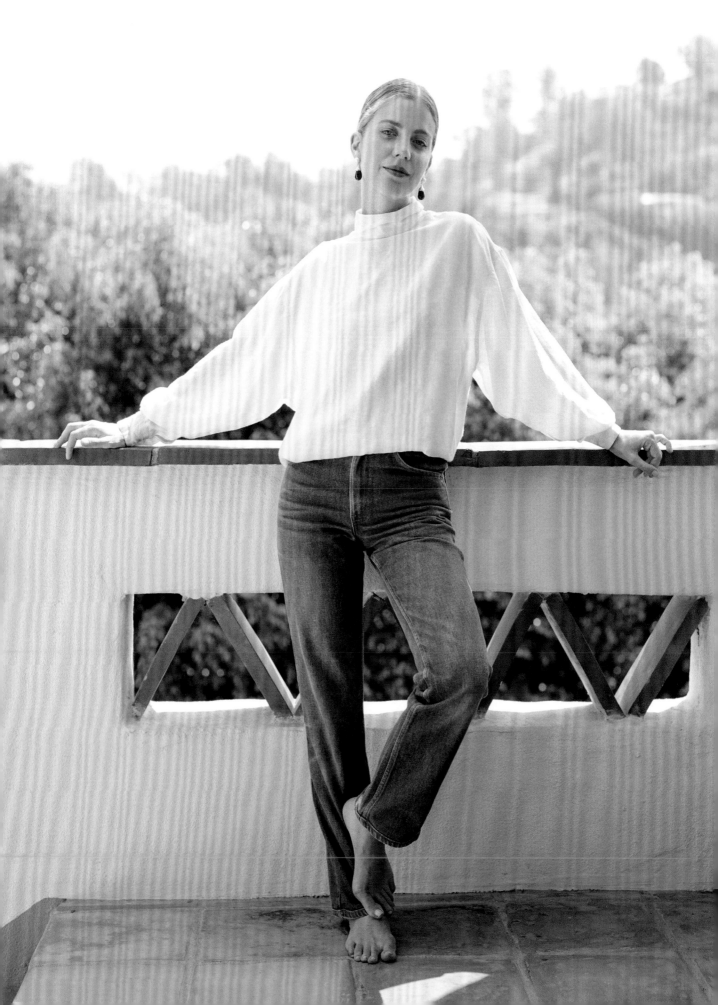

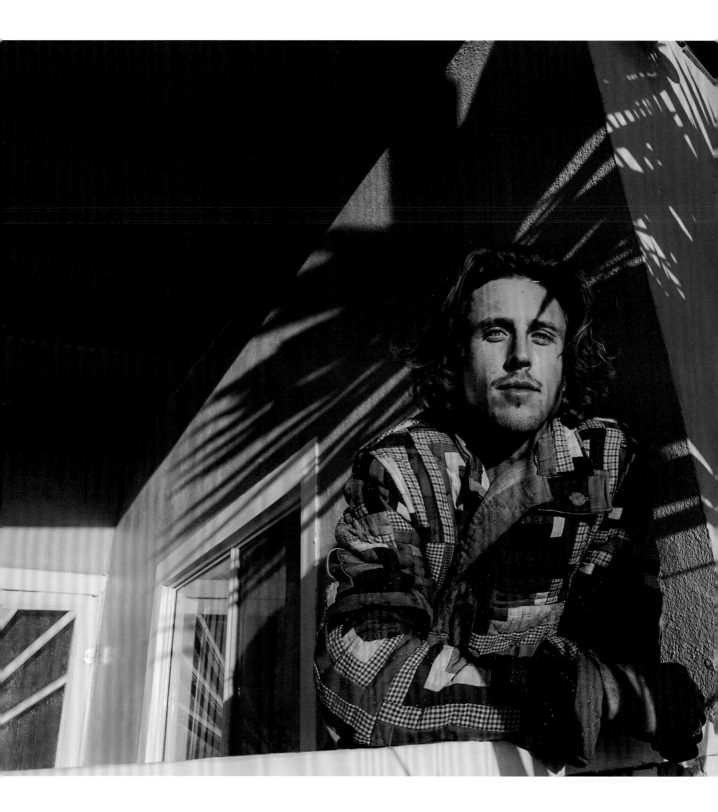

Designer Tristan Detwiler. Photographed by Si Li.

STAN, ENCINITAS, CALIFORNIA

"If there's good waves, I surf all morning, and if there's no waves then I come back and I make clothes." Twenty-four-year-old Tristan Detwiler has been riding out the pandemic at his parents' place in Encinitas, California, sewing one-of-a-kind quilted jackets from found textiles in a converted garage. He launched his label, Stan, in 2019 while still at USC, where he studied design, competed on the surf team, and sewed patches on his frat brothers' shirts. "I grew up just making, being free with my hands, open to anything—sculpting, fine art." At 12, he and a skateboarding friend took up knitting. Vintage quilts are his medium now, because he appreciates the stories they tell. "What makes Stan different is you can feel that it was handmade and passed through a certain family," Detwiler says. "It's not just like a generic T-shirt. You feel like you're a part of something and carrying on something."

ABOVE: A pendant from Ataumbi Metals. OPPOSITE: Designer Keri Ataumbi in her studio. Photographed by Mary Sloane.

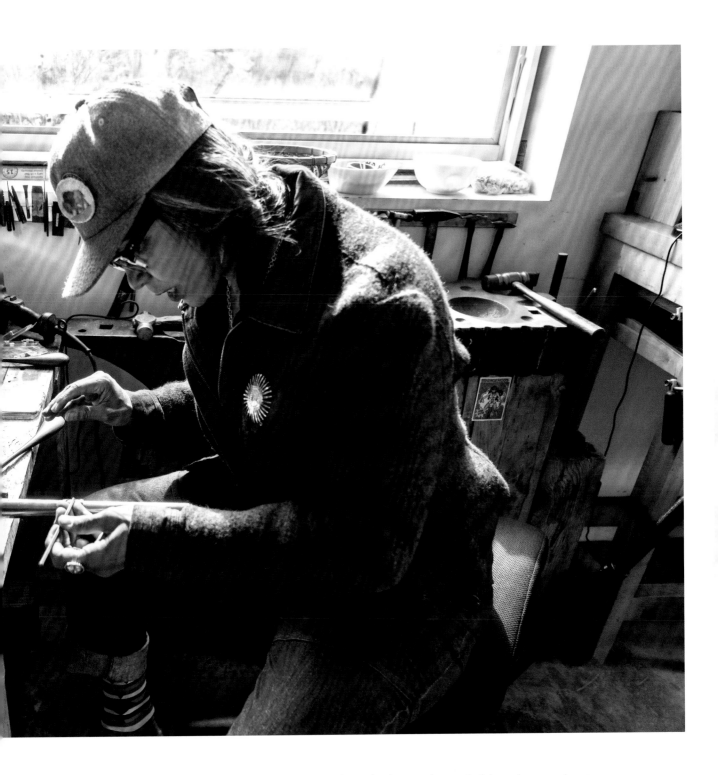

ATAUMBI METALS, SANTA FE, NEW MEXICO

Though Kiowa jewelry designer Keri Ataumbi is from Wyoming's Wind River Reservation, she designs and creates in Santa Fe, where she has been based since 1990. "I live in the Cerrillos Hills, which have old turquoise mines in them," she says. "Every time we're blessed with rain, turquoise or tools like arrowheads come up out of the ground, and I've incorporated them into my jewelry."

Her work mixes precious materials, such as gemstones or diamonds, with such found natural materials—she's also used porcupine claws and cast acorns for pieces, or transferred the pattern of leaves onto metal. The jeweler, who comes from a long line of artists, also mentors fellow makers in her community. "Those of us who know how to make something with our hands," she says, "have a responsibility to teach the next generation how to do that."

A view of the Cerrillos Hills in New Mexico.
Photographed by Mary Sloane.

ACKNOWLEDGMENTS

Thank you to Taylor Antrim, Chloe Schama, and Corey Seymour for their attentive edits, and to Raúl Martinez, Parker Hubbard, and Aurelie Pellissier Roman for their insightful visual direction. Christian Allaire, Brooke Bobb, Laird Borrelli-Persson, Charlotte Diamond, Emily Farra, Marley Marius, Chioma Nnadi, Janelle Okwodu, Nicole Phelps, Liana Satenstein, Sarah Spellings, and Steff Yotka performed the immense task of assembling the text of this book. Its direction and editorial curation was led by Mark Holgate and Virginia Smith, with special gratitude to Naomi Elizee, Alexandra Gurvitch, Willow Lindley, Alexandra Michler, Mai Morsch, Daisy Shaw-Ellis, Madeline Swanson, and Ciarra Lorren Zatorski for their help selecting and liaising with designers; Nic Burdekin, Lindsey Law, Fabbiola Romain, and Elizabeth Yowe did the work of getting those designers photographed (and beautifully). Thank you to Robyn Lange and Timothy Herzog for their additional image research, and thank you to Eliseé Browchuk and Toni Boyd for securing and tracking permission agreements. David Byars, John Mok, and Hollis Yungbliut managed the production process with grace and forbearance. Thank you also to David Agrell, Robin Aigner, John Banta, Mira Ilie, and Christiane Mack. Our gratitude goes out to Anthony Petrillose at Rizzoli for his support and enthusiasm for this project. And our deep appreciation to Anna Wintour, without whom this project would not exist.

CREDITS

Book design by Parker Hubbard

13: Art Partner. **15:** Courtesy of the Artist/Pierre-François Ouellette Art Contemporain/Stephen Bulger Gallery. **17:** Trunk Archive. **18:** George Barkentin, 1967. **19:** Condé Nast Archive. **21:** Suzane Carson/Michael Ochs Archives/Getty Images. **23:** Allyssa Heuze/Trunk Archive. **34–35:** Hair, Nikki Nelms; makeup, Grace Ahn. Fashion Editor: Alex Harrington. **44–45:** Hair, Tamas Tuzes; makeup, Courtney Perkins. Fashion Editor: Alex Harrington. **48–49:** Hair, Tamas Tuzes; makeup, Courtney Perkins. Fashion Editor: Alex Harrington. **66–67:** © 2021 Calder Foundation, New York/Artists Rights Society (ARS), New York. **109-110:** © Colby Deal/Magnum Photos. **148:** Hair, Barb Thompson; makeup, Lindsey Smith. **163:** Hair, Miles Jeffries; makeup, Dillon Peña. Fashion Editor: Alex Harrington.

First published in the United States of America in 2021 by
Rizzoli International Publications, Inc.
300 Park Avenue South
New York, NY 10010
www.rizzoliusa.com

Copyright © 2021 Condé Nast
Foreword: Anna Wintour

Publisher: Charles Miers
Associate Publisher: Anthony Petrillose
Project Editor: Gisela Aguilar
Production Manager: Kaija Markoe
Design Coordinator: Olivia Russin

Printed in China

2022 2023 2024 / 10 9 8 7 6 5 4 3 2

ISBN: 978-0-8478-7103-2
Library of Congress Control Number: 2021934322

Visit us online:
Facebook.com/RizzoliNewYork
Twitter: @Rizzoli_Books
Instagram.com/RizzoliBooks
Pinterest.com/RizzoliBooks
Youtube.com/user/RizzoliNY
Issuu.com/Rizzoli

COVER: TOP ROW, FROM LEFT: Photographed by Justin French; Sarah-Leila Payan; Daveed Baptiste; and Daniel Arnold. CENTER ROW, FROM LEFT: Photographed by Todd Hido; June Canedo; Alissa Bertrand; and James Branaman. BOTTOM ROW, FROM LEFT: Photographed by Sharon Lockhart; Johnson Hartig; Clifford Prince King; and Tierney Gearon.